CALLIGRAPHY & LETTERING

A MAKER'S GUIDE

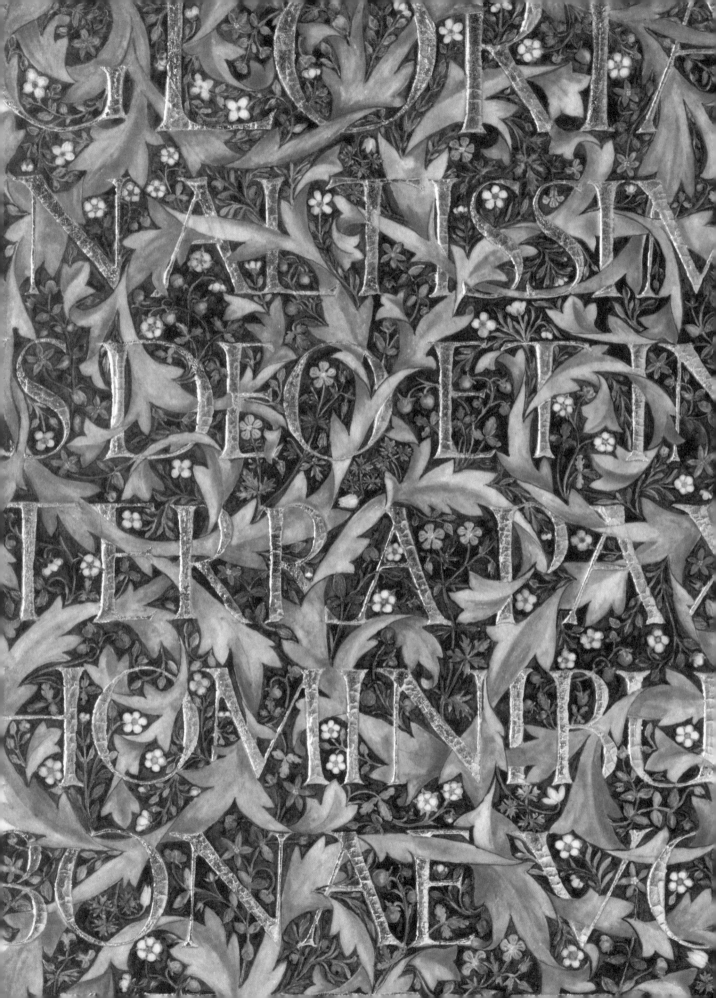

CALLIGRAPHY & LETTERING

A MAKER'S GUIDE

With over 200 photographs and illustrations

First published in the United Kingdom in 2019
by Thames & Hudson Ltd, London, in association
with the Victoria and Albert Museum, London

Calligraphy & Lettering: A Maker's Guide
© 2019 Victoria and Albert Museum, London/
Thames & Hudson Ltd, London

V&A images © 2019 Victoria and Albert Museum, London
Illustrations and project photography © 2019
Thames & Hudson Ltd, London
Text and layout © 2019 Thames & Hudson Ltd, London

See also Picture Credits p.176

Design by Hyperkit
Illustrations by Eleanor Crow
Projects commissioned by Amy Christian
Project photography by We Are Studio

British Library Cataloguing-in-Publication Data
A catalogue record for this book is available from
the British Library

ISBN 978-0-500-29430-7

Printed and bound in China by Toppan Leefung
Printing Limited

To find out about all our publications, please visit
www.thamesandhudson.com. There you can subscribe
to our e-newsletter, browse or download our current
catalogue, and buy any titles that are in print.

Frontispiece: Louise Lessore Powell, *Gloria in Altissimis Deo* manuscript leaf (detail), 1905, Great Britain
Ink and pigment on parchment, 20 x 15 cm (7⅞ x 6 in.)
National Art Library, V&A: MSL/1959/4396

Back cover images (clockwise, from top left):

Francesco Moro of Pozzoveggiano, leaf from *Arte della strozaria e farsi perfetto stroziero* (detail), 1560, Italy
Ink and gold on parchment, 23 x 16 cm (9⅛ x 6⅜ in.)
National Art Library, V&A: MSL/1946/1485

Tanchū Terayama, *Yūen* (detail), 2006, Tokyo, Japan
Sumi ink on paper, 136 x 64 cm (53⅝ x 25¼ in.)
V&A: FE.56-2008, Given by Mrs Yō Terayama,
Bequeathed by the artist to the V&A

Monsieur Oudry, Plaster cast of Trajan's Column
(detail), *c.* 1864, Paris, France
Painted plaster cast, 35 m (114 ft 10 in.) tall
V&A: REPRO.1864-128

Don Silvestro dei Gherarducci et al, Leaf from a Gradual
(detail), *c.* 1392–9, Florence, Italy
Water-based pigments, gilding and ink on parchment,
57.5 x 40 cm (22¾ x 15¾ in.)
V&A: 3045

Denise Lach, *August* (detail)
Photoengraving
Courtesy of Denise Lach

Letter sample, *c.* 1900, Great Britain
Oil and gold leaf on glass, 30.5 x 30.5 cm (12⅛ x 12⅛ in.)
V&A: 107-1955, Given by Mr H. F. Brock

V&A Publishing
Supporting the world's leading
museum of art and design,
the Victoria and Albert
Museum, London

CALLIGRAPHY & LETTERING TODAY

Denise Lach is a France-based calligrapher and conceptual lettering artist. She teaches lettering design and screenprinting at The Basel School of Design and has led calligraphy courses and workshops worldwide. Her work is shown internationally, and she is the author of several books, including *Journeys in Calligraphy* (2015).

Learning classic calligraphy is primarily a lesson in precision and humility. Mastering different writing styles and their distinctive features allows you to build up a body of skills.

It is only once you have absorbed these skills that you are able to detach yourself from them, and see them as the building blocks of creative freedom. This process leads us to contemporary calligraphy, which often involves moving towards a personal form of expression and leaving behind hard-earned knowledge and even legibility. It's sometimes difficult to give up beautiful historical scripts – uncials, bastardas, chancery hands – simply because the words are from the present rather than the past.

As far as my own work is concerned, what interests me most is the potential for texture, experimentation and playfulness: weaving words together with poetry and smoothness or with aggression and violence, combining them with calligraphic grace or left-handed awkwardness, taking a playful approach to tools, supports and media. What happens to letters if we etch them onto a copper plate with acid, drizzle them in chocolate onto a lithographic stone, or simply emboss them onto plain white paper, so they are visible only when the light shifts? Scripts lend themselves well to all kinds of experiments; they are inexhaustible and many-faceted, provided that we respect and feel a bond with them. Lettering regularly appears on walls in the form of street art, where it is given a highly imaginative graphic treatment and takes on unexpected characteristics. Flawlessness and legibility are no longer essential components of a composition, because the goal is not to communicate a message but to engage the emotions.

Modern life prizes speed and efficiency. Is it a reaction against the overwhelming grip of the virtual that an increasing number of people are now rediscovering traditional crafts? Are screen and keyboard overload driving us back to the source of handwritten scripts? Will the tactile pleasure of writing tools and the sensuality of fine paper lead us to embrace the beauty of lettering once again? Are slowness and concentration suitable

antidotes to a world of constant channel-hopping? It is important to rediscover the potential of the handwritten. It offers countless enticing possibilities that can start us out on a quest for aesthetic appeal and personal expression. You don't need to possess any particular artistic skills or devote yourself to the study of classical calligraphy in order to enjoy the pleasure of playing with letters. Nor do you need a great deal of space or equipment. You can begin even on a small budget, without going anywhere.

Script is everywhere. In many different fields, graphic designers and artists are making use of handwritten strokes in logos, textile designs, ceramic motifs and more. It is something of a shame that art schools no longer teach calligraphy, but instead a more general concept of lettering that tends to focus on typography. Nonetheless, many aspects of the written word are complementary. In our everyday environment, in the media and in advertising, classical and contemporary calligraphy, lettering, typography and graffiti can merge and evolve together.

The enduring fascination and evocative power of calligraphy may lead us to wonder about its place in the world of art. Is calligraphy compatible with art? Has contemporary calligraphy succeeded in carving itself a place in the realm of creative expression? When the intrinsic constraints of lettering are removed, a new dimension is opened to us, as are the gates to many other disciplines.

Calligraphy remains a particularly significant element of Chinese, Japanese and Islamic fine arts. In the West, however, contemporary calligraphy is a poor relation of art, and exhibitions and publications on the subject have yet to reach a wider audience. Let us hope for the continued renaissance of handwritten script, because it possesses the ability to express the essence of our being.

Denise Lach, *l'idee*, 2017

Denise Lach, *une certaine idée de l'ordre* (detail), 2017

Denise Lach, *texture graphique 4*, 2017

Denise Lach, *calligraphie illustrée*, 2017

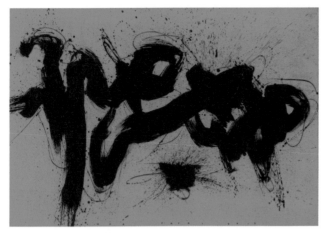

Golnaz Fathi, *Untitled*, 2017
Acrylic on canvas, 130 x 190 cm
(51¼ x 74⅞ in.)

Susie Leiper, *What is an
artist book?*, 2012, Scotland
Temporary wall, 3 x 3 m
(9 ft 10⅛ x 9 ft 10⅛ in.)

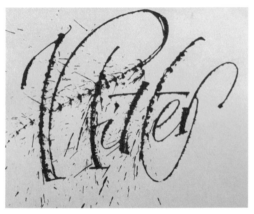

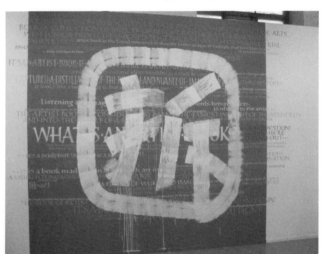

Paul Antonio, *Ruling Pen Plitter*, 2017
Black stick ink on paper, 16 x 16 cm
(6⅜ x 6⅜ in.)

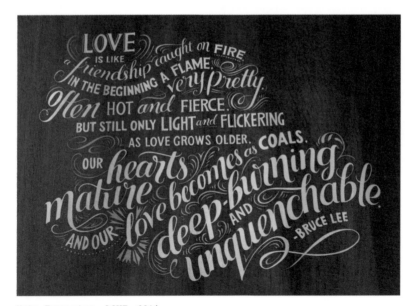

Kate Forrester, *LOVE*, 2014
Wood marquetry, approx. 60 x 80 cm (24 x 32 in.)

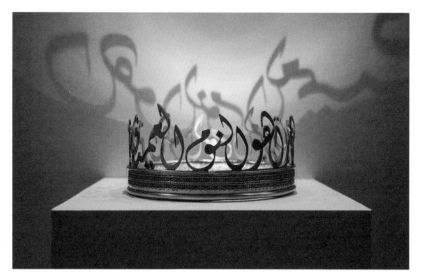

Soraya Syed, *A Deep Sleep*, 2016
Brass, diameter 19 cm (7½ in.)

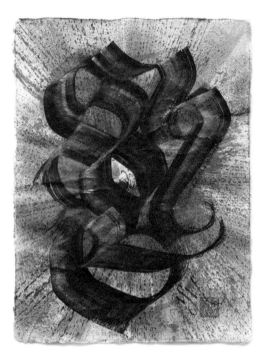

Niels Shoe Meulman, *Anniversary Piece #22 (35 years of Shoe)*, 2014
India ink and acrylic on handmade mulberry paper, 70 x 100 cm
(27⅝ x 39⅜ in.)

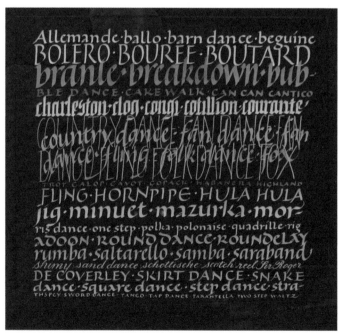

Gerald Fleuss, Terpsichore, 1995
Gouache on Ingres paper, 24 x 24 cm (9½ x 9½ in.)

TOOLS & MATERIALS

This section outlines the equipment typically used for calligraphy and lettering, some of which you may already have at home. The items shown here will be useful for many of the projects in this book, and they can all be found at arts and crafts suppliers and online. Where necessary, additional tools and materials are included in the lists at the start of each project.

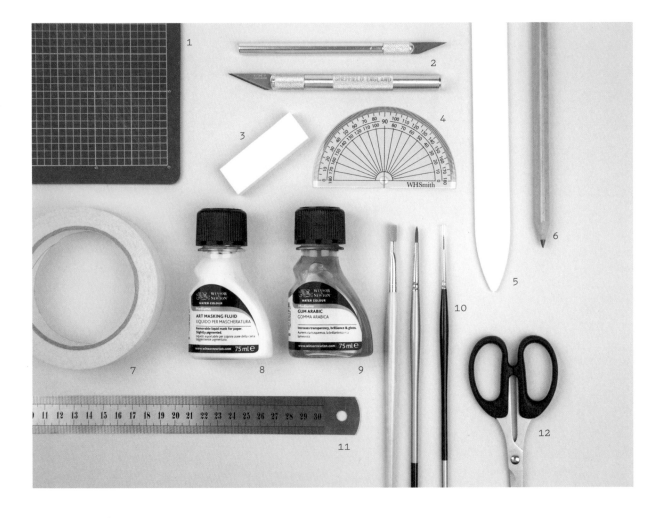

Basic equipment

Cutting mat (1)
A self-healing cutting mat will help to protect your working surface and keep scalpel or knife blades from blunting so quickly. Alternatively, use the thickest piece of card you can find.

Knife (2)
Preferably with disposable blades or blades that can be sharpened. Scalpels have differently shaped blades, but these can snap if too much pressure is applied. Craft knives are especially good for cutting card or multiple layers of paper.

Eraser (3)
A good, soft one will not smudge.

Set square or protractor (4)
30 degrees and 45 degrees are useful for drawing angles when practising letters or making margins.

Bone folder (5)
For scoring and folding paper. Folders are available from suppliers of bookbinding materials.

Pencils (6)
HB and/or B for drawing lines and making double pencils (see p. 36). Soft pencils will blunt easily and give an inaccurate line, so need to be sharpened often. Fine propelling pencils can take a softer lead and remain sharp.

Masking tape (7)
Will secure paper firmly and can be lifted off again.

Masking fluid (8)
A rubber-like solution that is used in a pen and left to dry. A wash is then applied over it. When the wash is dry the masking fluid can be rubbed off, leaving the paper to show through.

Gum arabic (9)
A few drops in gouache paint will help to 'fix' the paint on the paper.

Brushes (10)
Inexpensive brushes can be used for mixing paint and loading nibs. Use pointed 00, 0 or 1 fine sable brushes, or their synthetic equivalent, for finer work.

Ruler (11)
30 cm (12 in.) or longer.

Metal straight edge
Useful for cutting paper. Clear plastic rulers with one metal edge are available.

Scissors (12)
Sharp scissors are useful for doing paste-ups, but should be avoided for trimming finished work; they will not give an accurate line.

Non-permanent adhesives
Cow gum, a non-permanent glue, was traditionally used, but repositionable glue or tape is now more common. Useful to enable layouts to be repositioned.

PVA glue
A white glue that dries clear and can be diluted. Preferably acid-free, so that it will not eat into the paper.

Paper

Documents were traditionally written on animal skin, which was expertly cleaned, scraped and prepared to give flexible, durable sheets. Vellum made from calfskin is still used by calligraphers today. Good handmade paper is a fine alternative; if it is acid-free it can last for hundreds of years.

Categories of paper
There are three categories of paper. *Machine-made paper:* Continuous lengths of paper made by machine and cut into sheets. *Mould-made paper:* Individual sheets made by machine. *Handmade paper:* Individual sheets made by hand.

Surface
The surface of the finished paper is affected by how it is dried. *Rough:* Sheets of paper dry naturally, and stay as rough as they were when removed from the blankets. *Not:* Sheets of paper are piled together and pressed again. The result is a slightly rough surface. *Hot pressed:* Sheets of paper are passed between heated metal rollers to give a smooth surface.

Size
In this book, the most commonly used paper sizes are A3 (11⅔ x 16½ in.), A4 (8⅓ x 11⅔ in.) and A5 (6⅚ x 8⅓ in.) These are all approximate – a little larger or smaller will not be a problem, and you can always cut pages to size.

Weight
Paper weight is measured in grams per square metre (gsm) or pounds per ream (lbs). A ream typically runs to 500 sheets of paper. Generally, the smaller the number the thinner or lighter the weight of the paper. Recommended paper weights are included at the start of each project.

An enormous range of papers is available and many suppliers offer

samples of the papers they stock, for a fee. These are useful if you are ordering online, as they enable you to try out the papers with your nibs and brushes before buying. Art shops generally stock papers that can also be used for painting, drawing or printmaking, while specialist paper shops stock a selection of papers for all purposes. Paper for finished work is better bought in large sheets than small pads. Be sure to buy enough paper for the work you are doing – buying just one sheet will put you under enormous pressure to get it right first time. You may also want to do trials on the paper before starting a finished piece, so keep this in mind when deciding how much you need.

Layout paper is semi-transparent and good for making roughs and layouts. Buy a large pad of as good a quality as possible, to help you make sharp lines of ink that do not bleed into the paper. Cartridge paper is a thick, high-quality paper, good for practising on. It is also used as part of a writing board (see p. 14).

Pens and fluids

A quill, hardened and cut to size by hand, is among the oldest writing tools. Writing with one takes practice, and most calligraphers working today use manufactured pens or brushes. Paints as well as inks can be used for writing. Experiment with using different tools to see what works best for you.

Calligraphy pens (1)
These disposable, felt-tipped pens are available with a variety of different pre-cut nibs.

Paints (2)
Gouache paints mixed with water write well in a dip pen. Add drops of water to achieve a consistency that flows through the nib without sticking, but is not watery. If you mix the colour the day before you need it, it will flow freely and evenly and be less sticky. Watercolour paints can also be used but are less opaque than gouaches.

Automatic pens (3)
These come in a variety of shapes and sizes and make many different types of line. They can be used successfully with either ink or paint.

Chinese stick ink (4)
This comes in stick form and is ground with water on a slate ink stone (6) to the density of black that is required. The blackness of ink sticks varies; generally, better quality ink sticks produce blacker inks. Matt black ink sticks are usually better than shiny black ones. Cut down on the grinding time to make watery greys (see opposite page).

Bottled ink (5)
The easiest to use and most widely available writing fluid. Use non-waterproof Indian ink. The waterproof version is very tricky to remove if left to dry on a nib. Ordinary fountain pen ink is too thin to use with a dip pen, and will not give even coverage. Coloured inks are also often very thin, and paints (2) may be a better choice.

Drawing acrylics and coloured fluids (5)

These can be used straight from the bottle, but vary in consistency and coverage. It is important to wash your pens or brushes thoroughly after use.

Fountain pens

These are available with calligraphy nibs and can be useful for quickly trying ideas or practising with limited time or space. They do not give as controlled a line as other pens.

Chalk (7) and chalk pens (8)

It can be hard to write accurately with traditional chalk sticks, so try chalk pens for a neater finish.

Dip pens (9) and nibs (10)

These consist of square-edged metal nibs, which are inserted into pen holders and used with or without reservoirs to hold the ink. Nibs are available in ten sizes. Check carefully to make sure that they are not split, badly formed or not clearly cut out. They can be used with bottled and stick inks and gouache and watercolour paints, as well as with other writing fluids and media for gilding. Left-handed calligraphers can buy oblique-left nibs for ease of writing. Pen holders come in various shapes. Find one that you feel comfortable with and buy several, so that you have a holder for each of the nibs you use in a piece of work.

Ruling pen

These have an adjustment screw which allows the width of the line to be altered. Traditionally used with a ruler, for ruling straight lines in paint or ink.

Calligraphy brushes (11)

These are firmer than regular paintbrushes, and can be used with bottled and stick inks and gouache or watercolour paints. Choose several square-edged and pointed brushes between 0 and 2 in size.

Grinding Chinese stick ink

Choose a large ink stone. This will allow you to establish a rhythm when grinding the ink. Add a little water to the ink stone and rub the stick into it in circular movements. Keep testing the ink on paper with a nib – continue grinding and adding water until you have a good black pool of ink.

Ground ink does not keep, so it is best to grind it fresh whenever you use it. The slate will eventually wear smooth with use, and will not produce black ink however long you grind. If this happens, roughen the slate with 400–600 grit wet and dry paper.

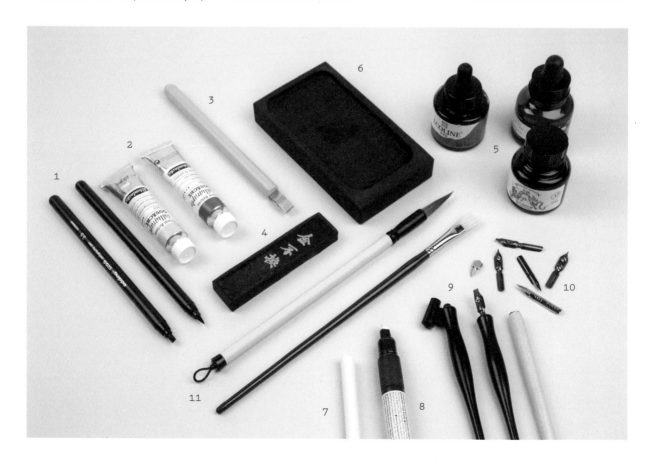

GETTING STARTED

Calligraphers need to sit comfortably and work against a firm, sloped surface. Setting up your writing board properly is therefore very important to the success of your lettering.

Setting up a work surface

Your board should be at least the size of an A2 (23¼ x 16½ in.) sheet of paper. Commercially made boards can be expensive, but a piece of plywood at least 5 mm (⅜ in.) thick, with its edges sanded smooth, is a good substitute.

Setting up a writing board

Tape a pad of twenty newspaper sheets covered with a sheet of cartridge paper onto the board, or use the reverse side of a piece of thick, smooth-surfaced wallpaper. This padding is necessary because the surface of the board itself will be too hard for a lightly held pen to write smoothly.

Finally, tape a 'guard sheet' made from the same cartridge paper or a piece of card across the board. This will help to hold your writing paper in position and protect its surface from any dirt on your writing hand. Position the guard sheet at about two-thirds the height of the board, so that your hand and eye are in line as you write and your arm is fully supported.

Left-handed calligraphers may prefer to place the writing paper and guard sheet so that they are at an angle.

Using a writing board

The diagrams on the opposite page show how the writing board can be used. In all three cases the board

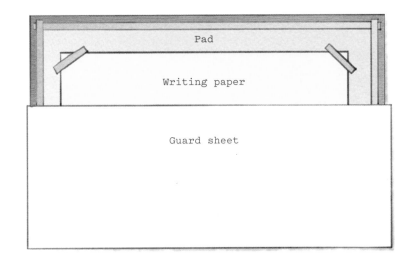

extends beyond and below the table top, so that it will not slip away from you. The angle at which the board is held should be determined by your comfort and by the work you are doing, but it will also affect the flow of ink to paper.

To prevent paper creasing, cut a section of cardboard tube and tape it to the bottom of the board, or tape a heavy piece of card so that it hangs freely from the bottom.

You must be able to sit upright and rest your forearm comfortably on the board, with your hand and pen on a line about two-thirds of

the way up. Keep your back straight, the chair tucked in and your feet flat on the floor. Sitting uncomfortably will cause backache and create tension in your writing arm and shoulders, which may affect your writing.

A good light source will ease any strain on your eyes. Daylight is the best. Steady, even light is important when mixing colours; artificial lighting can produce varying results. An adjustable lamp will provide the best kind of artificial light, as it can be moved to shine exactly where it is needed.

Positioning a board

There are different ways to ensure the correct board position.

1. The plywood sheet is rested on your knee against a table to make a simple and effective board. It is stable, can be positioned at any angle and you can easily reach the top of the board.

2. Two boards are hinged together. Heavy blocks, for example cloth-covered bricks, hold the upper board at the desired angle and also anchor the base board.

3. The hinged boards have hinged supports which slot into grooves in the base support, and pegs to stop the board from slipping away. This also shows the cardboard tube attached to the board.

The correct angle

The angle at which the board is positioned is as important a factor in the ink flow as the nib or reservoir you are using. Steepen the board for work that requires a slow, carefully controlled flow of ink. Flatten it if you want a speedy and plentiful ink flow.

Ink flow

Hold your pen at an angle of about 60–90 degrees from the board, whatever the slope. When the board is sloped at a shallow angle, the pen is held almost vertically and the ink flow is much faster than when the pen is held closer to the horizontal, on a board positioned at a steep angle.

 Keep your arm supported to ensure that your wrist and fingers are able to move your pen freely.

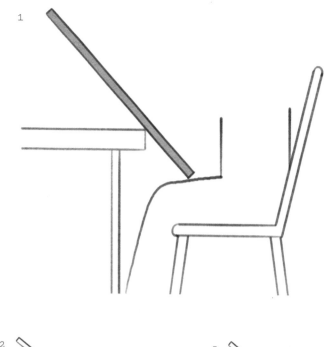

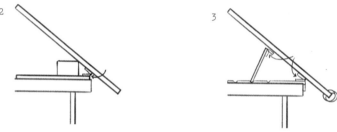

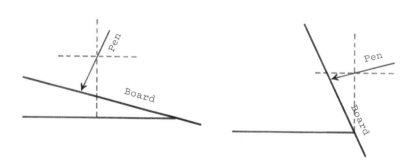

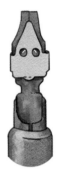

The triangular 'tongue' of the reservoir must be down from the nib end (left). If it is too close it will touch the paper. The reservoir must rest very lightly under the nib (above).

1

Apply ink into the space between the reservoir and the nib using a small paint brush. If you are using a nib without a reservoir, brush on the ink so that it covers the opening on top of the nib.

2

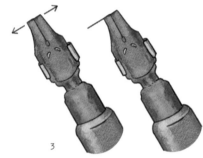

Side-to-side movements on the paper (or serifs on the beginnings of letters) will help to start the ink flow.

3

Beginning to write

These are the most basic pen calligraphy skills: how to put a nib and reservoir together, then how to load the nib with ink and start to write.

Attaching a reservoir (1)

This needs practice. If the reservoir is attached too tightly it will split the tip of the nib apart or prevent the ink from flowing onto the tip. If attached too loosely, the ink will blob or the reservoir will fall off. Always remove the reservoir after use and clean it with a toothbrush to avoid rust building up. Not all calligraphers use a reservoir – try with and without one to see which works for you.

Applying ink (2)

Use a brush to apply the ink under the reservoir or on the top of the nib if you are not using a reservoir – if you dip the nib straight into the ink it will be totally covered in the fluid, and it is essential that the ink stays only on one side of the nib to help keep the writing sharp. Clean the nib at regular intervals using a tissue or a cloth that does not shed fibres. This will prevent dried ink from building up on the nib. Always wash and dry nibs after use.

Starting to write (3)

You may find that getting the loaded nib to write is difficult at first. Side-to-side movements or serifs on the beginnings of letters will help to start the ink flowing through the nib. If the ink flow is still a problem, check the following points:

- Is the surface of the nib too smooth to conduct the ink? This can happen with new or very shiny nibs, especially wide ones. Hold the nib in the flame of a match for a few seconds or lick its surface – the deposits will help the ink flow.

- Has the reservoir been attached too tightly?

- Has the paper picked up grease? A guard sheet (see p. 14) will prevent this from happening.

- Is there enough water in the ink? Add distilled water if the ink seems too thick or creamy.

Holding the pen

Right-handed calligraphers can hold the pen either up between the first two knuckles of the forefinger or down in the junction of thumb and forefinger. The first hold allows the pen to move flexibly between the fingers. There is less flexibility with the second hold, but many people find that it is more comfortable and gives them greater control. This hold is adaptable for left-handed calligraphers.

The hold affects the way the nib makes contact with the paper and the flow of ink onto the paper. The angle of the board is also important. The first pen hold works well with a steeper board angle, the second pen hold requires a shallower board angle.

Experiment to see which pen hold and board angle allows a steady ink flow from pen to paper.

Setting line spaces

The space between the upper and lower guidelines for your writing – the 'x-height' – is the height of a letter with no ascenders or descenders, for example 'o'. This space is set by the width of the nib you use.

Below, top Draw the bottom guideline first. Then, make a series of horizontal 'steps' with your pen. Each step must begin at the top of the previous one. Keep the nib at a 90 degree angle and hold it vertically; this will help you to make accurate steps up from the line.

Bottom Draw the top guideline – the top point of the steps sets the top writing line for the x-height of the letters. If you are writing a majuscule script like Roman Capitals, this will be the height of all your letters. If you are writing a minuscule script, letters like 'd' and 'g' will extend above or below this space.

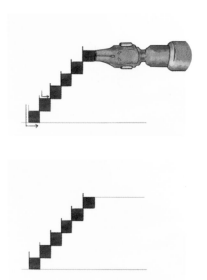

Pen angles and pressure

If the widths of the strokes in your writing are inconsistent, it could be because the angle has changed or the pressure is uneven. Always be aware of your pen angle and how your hand and fingers move – keep it as consistent as you can. Applying light pressure will make writing quicker and easier. Work steadily and be aware of the rhythm you create as you make the strokes. Relax.

Below, top Always keep the full square edge of the nib in contact with the paper.

Centre The stroke should not be wider than the nib. This happens when heavy pressure on the nib causes its tines (the two sides of the tip) to splay.

Bottom Uneven strokes are the result of the nib not making full contact with the paper, so that you apply more pressure to one side than the other. This can happen when the writing surface is too hard.

Practising pen strokes

Draw lines across a sheet of layout paper and use these as a base line. Hold your pen with the nib at an angle of 30 degrees to the writing line – draw a 30 degree angle at the beginning of the line as a check.

Begin to practise writing – you could repeat the same, single letter, or just practise making curved, diagonal and straight pen strokes in different combinations. Focus on keeping the 30 degree angle consistent while you write, and make sure that your upright strokes do not slope backwards. To make diagonal strokes, hold your pen at a slightly steeper angle, nearer to 40 degrees.

Look at the width of the strokes along the line to see if they are consistent – think about whether you are applying the right amount of pressure as you write. Look at the beginnings and endings of the strokes to check that you have kept the pen angle consistent.

Straight strokes should form a series of parallel lines with even spaces between them. Curved pen strokes should be balanced and appear to sit upright. When straight strokes lead into curves or arches, the straight strokes should be upright and parallel.

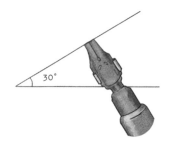

30°

SKELETON LETTERFORMS

The fine examples of consistent letterforms that can be found in Roman inscriptions are a sound starting point for looking at good lettering. They are mathematically regular, but have the life and visual balance that only a trained eye can add.

Edward Johnston, the father of the modern calligraphy revival, wrote on the first page of *Writing & Illuminating & Lettering* (1917): 'Nearly every type of letter with which we are familiar is derived from the Roman capitals and has come to us through the medium, or been modified by the influence of, the pen.' It is not known for certain whether Roman inscriptional letters were geometrically based, but the carved letters are so well proportioned that it is conceivable that their makers had a method of ensuring consistency of shape and form.

As a result of his research into early manuscripts and inscriptions, Edward Johnston used a geometric model to introduce his students to Roman capitals. The forms based on them are known as skeleton letters – the bare bones of letterforms.

Skeletons provide a foundation on which to build fine letters and, when written with some optical adjustments and finished well, can be very beautiful in themselves. A thorough knowledge of the relationship between letters' shapes and forms will give you the freedom to design and write good capitals and lower-case letters – and to apply these principles to all scripts.

The diagrams on the following pages explain the geometrical basis of skeleton letters and their spacing, and how to use them.

The basic geometric grid is a circle within a square (see opposite page). This offers an easy starting point, because both shapes are constant and vary only in size. They are also easily constructed and recognized. Skeleton letters sit within this grid and are based on the shape and area of the letter O, which follows the circle. In the exemplar shown on p. 19 and throughout this book, letters are grouped into 'family groups' according to their shapes rather than the order of the alphabet, so that the relationships between them can be clearly seen.

Spacing the letters ultimately depends on your visual judgment, but actual measurements offer a tangible starting point and will help to train your eye. The basic rules for combining letters are given in the diagrams on p. 21 – follow these and then judge the overall balance of the spaces in your writing. Look at the shapes of the spaces inside the letters together with the shapes of the spaces between them.

Evenly spaced letters are crucial to the smooth reading of a piece. Often, lettering is too closely spaced, which stops the eye from distinguishing letters with ease. Judging good spacing will come with both writing and looking at well-spaced lettering.

Family groups

Basic grid
A circle within a square is the starting point. ⅛ of the square is cut off each side to give a rectangle, and the lines cut portions off the circle so that the area of the rectangle is visually equal to the area of the circle.

Round letters: O, C, D, G, Q
O and Q follow the circle. D occupies the same visual area as O. C and G follow the circle, but the top and bottom strokes are flattened, to allow the eye to move along the line to the next letter.

Rectangular letters: H, A, V, U, N, T, X, Y, Z
H sits on the rectangle and occupies the same visual area as O. Place the crossbar slightly above centre, or it will appear to drop below centre. U follows the lower section of the circle. T's crossbar sits between the ⅛ lines, as do Z and N. Y has a central downstroke. The crossbar of A is lower than the centre, so that the top and bottom spaces are visually balanced.

Wide diagonal letters: M, W
W is as wide as two Vs; V sits within the rectangle, so W is as wide as two rectangles side by side. The central section of M is the same as V; the legs extend to the corners of the square.

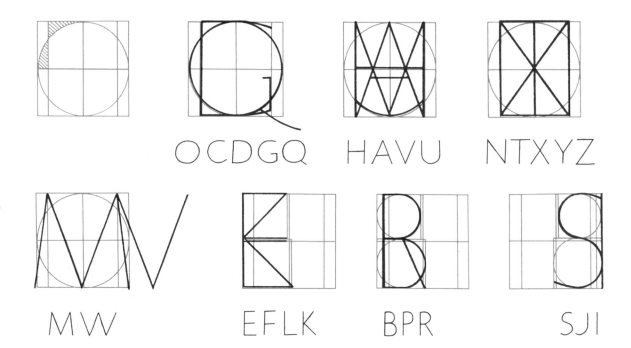

OCDGQ HAVU NTXYZ

MW EFLK BPR SJI

Narrow letters: E, F, L, K, B, P, R, S, J, I

These are based on diagrams which occupy half the area of the large square. The ⅛ line is also divided in half to become, in effect, ¹⁄₁₆ of the large square. The top square is slightly smaller and the bottom one slightly larger than ¼ of the large square, but both are true squares. E, L, F and K's upright strokes sit on the outside of the squares. The upper and lower strokes of J and S are flattened, for the same reason as those of C and G. I is a straight line. The curved bowls of B, P and R follow the circles.

Using the theory

The strict geometric diagrams above offer a useful starting point from which to discover letterforms. As the diagrams stand, they give letters that are technically related in shape and form. Aesthetically, though, these letters can look rigid

or even uncomfortable when they are together. Do not be afraid to modify your letters – it is what they look like that is ultimately important.

The narrow letters B, P and R are good examples of this. Drawn geometrically, their bowls look small; indeed, the internal spaces of the top bowls are less than a quarter of the area of a D. The bowl of P, and to some extent the bowl of R, needs to be enlarged a little in order to balance visually with the space below it. The geometric diagrams for the narrow letters B, P and R are, however, useful to show how the shapes of the bowls should relate to the circle and square and offer a first step towards understanding their form.

As Edward Johnston wrote, 'the tension lies in the difference between an exemplar and the free interpretation of it – spontaneous writing is dependent on the free movement of the hand.'

Learning the basics of skeleton capitals

Take time to construct the capitals geometrically so that you fix the proportions in your mind. Use a 4 cm (1½ in.) grid.

- Rule horizontal lines 2 cm (¾ in.) apart, then write the letters between the lines. Pay very close attention to their shapes and proportions. Write the letters in their groups, first in pencil and then with non-waterproof Indian ink and a narrow nib.

- Notice the white shapes inside the letters as well as the black letter shapes themselves.

- Remember the circle – natural handwriting tends to be narrow, and making circle-based skeletons can be difficult when you start to write skeleton letters for the first time.

Practice alphabet

Practise writing out skeleton capitals, first in pencil and then in pen, using the alphabet below as a reference for good, consistent letterforms.

ABCDEFGHI
JKLMNOPQ
RSTUVWXYZ

Adapting skeleton capitals
Use a fine nib held at an angle of approximately 30 degrees. The easiest way to make the letters look more 'finished' is to add small serifs – endings at the top and bottom of the strokes – with the nib moving from left to right so that it produces a small, thin stroke at an angle to the main strokes. Serifs should be light and fine: too much ink or a damaged nib will result in heavy serifs. Serifs can also provide a useful lead-in to the main strokes.

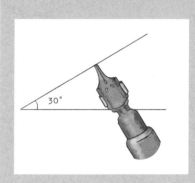

ALPHA
BETA

Using skeleton letters

Skeleton capitals can be used by themselves as elegant letters. Once you are at ease with writing them, you will find that they have many uses. Knowledge of their form will give you a valuable foundation and basis from which to develop, and will help you to examine the relationships between letters of any script in terms of form and shape.

Remember that letters are spaced visually, and it is essential to ensure that there is an equal visual balance of space inside and around them. You may need to make optical adjustments so that the letters sit together in a visually pleasing way.

When you are confident about writing skeleton capitals and sure of the way their forms relate, you will be able to use them in a freer, more relaxed way. With practice, the shapes of the letters will become second nature, and you will find it easier to get their spacing right. As you relax, you will find that your writing speed increases and may result in your letters sloping slightly forwards. This is fine – it adds vitality to your work. Just let it happen naturally.

It is worthwhile working hard to master skeleton capitals. When you feel confident of your ability to write individual letters, practise them in their family groups, then progress to writing out words and phrases.

Spacing

The starting point is the space between two upright strokes (1): ⅝ of the height of the letters.

When a diagonal letter follows an upright (2), the diagonal stroke is moved closer, so that if it were upright it would sit on the ⅝ space guideline. When two diagonals are adjacent (3), they are positioned similarly, so that the visual area between them is the

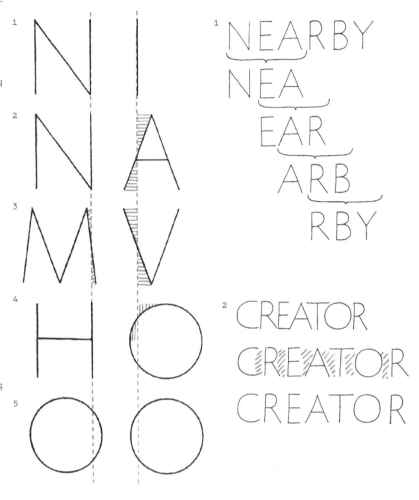

same as the two upright strokes.

When a circle and an upright stroke are adjacent (4), the circle comes closer to the upright by overlapping the ⅝ line. The area between them remains visually the same as the space between two upright strokes.

Adjacent round letters (5) come closer to compensate for the space around the curves, ensuring that the visual area between them remains the same.

Checking spacing (1)

Begin by checking the space between two upright strokes, and work from that until you have looked at the

whole word. Look at groups of three letters at a time, as shown above. The balance of the two spaces between them will be much more noticeable. Too small a space between two letters will pull them together, too large a space will push them apart.

Visual balance (2)

The letters should balance visually, so that neither holes nor dark patches are created. In closely spaced letters like the example at the top, O will stand out as a hole. In evenly spaced letters, it takes its place and should not be any more noticeable than other letters.

Skeleton minuscule letters

Minuscule or lower-case letters are constructed on a similar grid to capitals – a circle within a square and a rectangle of the same area as the circle. Although they are not as commonly used as the capitals, understanding the construction of skeleton minuscules will prepare you for looking at and understanding other minuscule letterforms.

Round letters: o, c, q, d, e, b, p, g
Round letters follow the circle. The top curves of c, q and d are flattened, as is the bottom curve of p. To avoid confusing the eye, g is made of a circle between the ⅛ lines and a lower, open or closed oval-shaped bowl. The back curves of c and e follow the circle, but are often slightly straightened.

Straight letters: i, j, l, t, f, k, s
The bottom curves of l and t follow the curve of o, but i does not have a curved base. The top curve of f is slightly flattened. s is hard to draw diagrammatically, but the bowls should relate to the circle.

Arched letters: r, a, u, h, n, m
These follow the top curve of o. m is twice the width of n. u follows the lower part of o.

Diagonal letters: v, w, x, y, z
w is twice the width of v. The top of x is inside the rectangle and its base is just outside it. The base stroke of z is just a little longer than the top one.

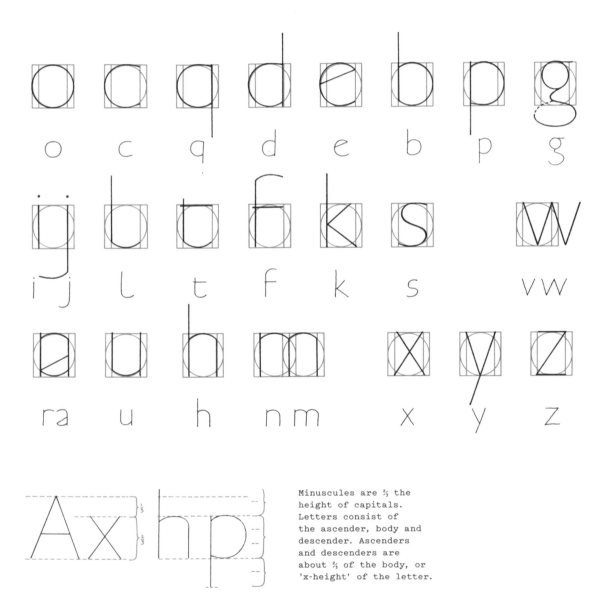

Minuscules are ⅔ the height of capitals. Letters consist of the ascender, body and descender. Ascenders and descenders are about ⅔ of the body, or 'x-height' of the letter.

Practice alphabet

Practise writing skeleton minuscules, first in their family groups or in alphabet order and then, as you gain confidence, grouped into words.

abcdefgh

ijklmnopq

rstuvwxyz

skeleton minuscules

Letters are spaced visually,
with even spaces inside and
between the letters and an
'O' space between words

MAKING A LAYOUT

Although it is vital to practise writing letters, the best way to make progress with your calligraphy is to write out finished pieces of work. This will give your writing a sense of purpose and encourage you to push your calligraphic skills further.

There are two main ways to set about making a piece of calligraphy. Some calligraphers start with the words they wish to use and develop their ideas from there. The words suggest the script and the size and colour of the letters, as well as their shape and position on paper. Other calligraphers start by visualizing a piece of work and find the words that best express this image.

Choose a poem or quotation and write it out on lines two x-heights apart, so that there is plenty of interlinear space. The choice of writing style, letter size and weight will depend on the text. For example, if you select a poem about tall grasses it may be more suitable to write it in tall, lightweight letters than in small, heavyweight letters.

The next step is to decide on the layout. The positioning of words and lines on paper is all-important and the diagrams on pp. 25–26 illustrate standard layouts as well as some more unusual ones. They also show how margins help to frame the words, and how the space they create around the text influences the feel of a piece and how readers respond to it. Before deciding on a layout, it is useful to make a paste-up and begin to decide on the margins for the piece.

Making a paste-up

1. Write the text out on layout or scrap paper. The lettering must be as good as you can make it, so that you have an accurate guide from which to take measurements for the final piece.

2. Separate the text into strips by cutting between the writing lines with scissors or a knife.

3. Lay the strips on another sheet of layout paper and move them around to get an idea of the various design possibilities. Cut between the words if necessary, to experiment with different shaped layouts, but always remember that the text must make sense to the reader.

4. When you have selected a layout, paste the strips down using repositionable glue or a glue stick.

5. Take careful measurements from the pasted-down strips with a ruler. Alternatively, make marks on a strip of paper and mark them on the paper you will be using for your final piece.

For greater accuracy, you may want to make a final rough: rule up another sheet from the paste-up and write out the whole piece. It is a good idea to make several photocopies of your written text, as this will enable you to make a number of paste-ups from which you can select the one that is most suitable. Make sure to paste the photocopied strips down on paper of the same shade, as otherwise the image of the design will be disturbed.

Standard layouts

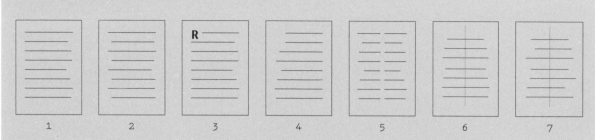

Aligned left (1) Each line starts from a vertical line on the left of the paper. This is a standard layout, but the hard edge can be severe, especially if line lengths vary, giving a broken right edge with space from the margin entering the text block.

Aligned left (2) Two vertical lines for alternate lines of text give an even but softer left-hand edge, and allow white space from the margin to break into the text.

Initial emphasis (3) An initial in the left margin acts as a guide for aligning the text left.

Aligned right (4) Each line must be carefully measured and then written to exactly the same length as the layout. This is difficult to do but can be necessary if a specific effect is required.

Centre space (5) A layout can consist of two sections, one aligned right and one aligned left, with a central column of space.

Aligned centrally (6) Each line of a layout is measured, their central points are marked and the lines are placed equally on either side of a centre line. This gives a formal, balanced layout.

Visually centred (7) The lines are visually balanced around a centre line but placed asymmetrically. The overall appearance is balanced yet informal.

Choosing the margins

1. Cut four strips of coloured paper or use four long strips of coloured card to make two right-angled corners.

2. Move the coloured strips or corners in and out around the text, until the space that surrounds it looks comfortable with the words. If you pin the piece on the wall and look at it from a distance, you will be able to get an overall view of the work.

3. Mark the insides of the corners or strips and, using these marks as a guide, draw pencil lines that meet at right angles. Use a long ruler and the 90 degree corner of a set square to make sure that the angles are accurate.

4. Trim these lines with a knife and metal-edged ruler. If the work is to be framed, allow an extra 6 mm (¼ in.) around the marked margin line for the rebate of the frame.

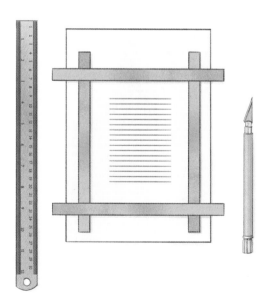

Considering margins

Standard spacing (1) As a general rule, allow the same amount of space at the sides and top of the text and more space at the bottom.

Equal spacing (2) If the amount of space at the bottom of the text is the same as at the top and sides, the work will appear to drop downwards.

Long vertical layout (3) The margins at the side can be narrower than those at the top and bottom.

Long horizontal layout (4) Wider margins can be left at the sides than at the top and bottom.

Asymmetric spacing (5) Text may be placed asymmetrically or towards the bottom or top of the page. The overall shape of the piece should reflect or respond to the shape of the text area.

Creating a whole (6) Margins may need to be bigger than other spaces – for example, those between title and text, verses in a poem or text and credit – so that the different elements rest together.

Spacing to avoid If the top and bottom margins are smaller than the other spaces, the text will pull outwards. If the space between text and title or text and credit is bigger than that between verses or paragraphs, the verses will seem to pull apart.

Margin size

Narrow margins When you are working on a textured piece of writing, margins can be kept narrow to emphasize the pattern of the writing (1). Narrow margins can make the spaces within a piece of work more noticeable (3).

Wide margins These emphasize the shape of a block of text (2). When wide instead of narrow margins are used for a piece, space within the text flows into and becomes one with the margins (4). For more on book layout and margins, see p. 53.

Layouts to treat with caution

Bottom-heavy text (1) Gives a feeling of heaviness and solidity. Heavier text at the top suggests light and growth.

Diagonals (2) Lines which align diagonally underneath each other pull the eye uncomfortably.

Weak centre (3) The space cuts in from the sides to narrow lines in the centre, creating a weakness.

Lack of centre core (4) Text wanders from side to side, which gives the page a lack of direction.

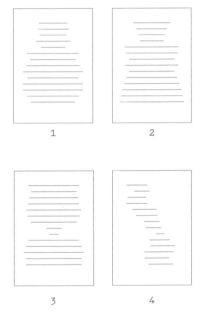

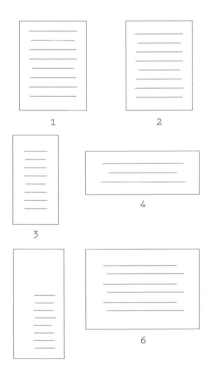

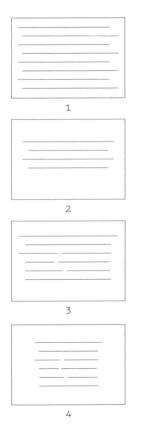

MAKING A FINISHED PIECE

When you have finalized the design of your work and have a paste-up or a final rough from which to work, the next step is to prepare your paper. This preparation is integral to the finished work, so it is important to spend time on this stage.

Determining the grain of the paper

During the manufacture of machine-made and mould-made papers, the fibres align themselves in one direction, which gives the paper a grain. It is important to determine which way the grain runs through the sheets you are using – rolling, folding and tearing paper in the direction of the grain is much easier than working against it. The grain in machine-made paper is usually easily found. In mould-made paper it is a little more difficult, and in handmade paper it is very difficult to detect or simply non-existent.

Storing and carrying paper

Store paper flat and protect it from dust. To transport sheets of paper, roll them with the grain to avoid creasing and slip the roll into a cardboard tube. Alternatively, wrap the sheets around a cardboard tube. Always lay the paper flat as soon as possible.

Folding paper

When thin and medium-weight papers are folded with the grain they usually fold sharply and easily. When they are folded against the grain the result is rough and imprecise.

To obtain a consistent, sharp fold in the exact place you wish, a line must be scored first. A bone folder is the best tool for this, but you can use any small, blunt instrument which will flatten and weaken the fibres and allow them to fold more easily. Fold the paper along the scored line and then run the folder along the folded edge to give a good, sharp crease. The folder can leave a shiny line on some papers. To avoid this, put a piece of layout paper between the bone folder and the paper.

A new bone folder is sometimes too thick and will score too wide a line. If this happens, sand down both the pointed and square ends until they are smooth and fine. Use coarse sandpaper first, and then progressively finer sandpapers.

Testing the grain in paper

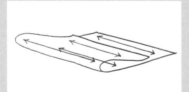

Bend the sheet of paper over without creasing it. If it lies down comfortably it is bending with the grain. If it is springy and bouncy it is bending against the grain.

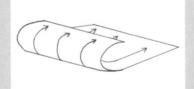

Fold the paper. Against the grain it will not give a clean, accurate fold. Folded with the grain it gives a sharp, clean line.

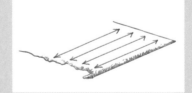

Wet one edge of the paper. If it cockles – buckling or pleating – it has been wetted against the grain. If it curves over and waves it is moving with the grain.

Cutting paper

Always use a very sharp knife to cut paper – a blunt knife will tear the paper instead of cutting cleanly. Use a metal-edged ruler. Put more pressure on the straight edge than on the knife when you cut, to avoid both edge and knife slipping.

If your knife is sharp, only a little pressure will be needed – nothing more than a stroking action, which can be repeated several times if necessary, depending on the thickness of the paper. Always be aware of the angle of the blade as you hold the knife. Try to keep the blade vertical, unless you want to create a bevelled edge to your cut.

Deckled edges

Sheets of machine-made paper generally have cut edges on four sides, and handmade and mould-made papers usually have deckled edges on two or all four sides of the sheet. Deckled edges are made by the pulp in the deckle, or frame, of the mould that is used during the manufacturing process. In the past, books written on paper traditionally kept the deckled edge on the tail (lower) edge and foredges, with a cut edge at the head (top) edge to avoid trapping dust.

A piece of calligraphy can be mounted or it can be left with the deckled edges showing, giving a simple decorative element to the presentation of the piece. If only one or two deckled edges on a sheet of paper can be used because of the size of a piece of work, it is possible to make a mock deckled edge (see opposite page).

Preparing the surface

Some paper surfaces can be difficult to write on. Where possible, if you are having real difficulty with your paper, it may be best to swap it for one that is easier to work with. If the paper you are using is too 'slippery' or does not take the ink easily, rub the surface gently with a soft pencil eraser before you start to write. If the ink or paint bleeds slightly into the paper, sandarac dusted onto the surface can help to prevent this. Sandarac is a resin that can be bought either ground or unground. If you buy the unground version, you will have to grind it very finely until it is an off-white dust before applying it to your paper. Put a little ground sandarac into a finely woven cloth pouch or small tissue, and stroke the paper lightly with the pouch or bunched-up tissue. Be sparing with the powder, as too much will make writing difficult and clog your pen nib. Use a dust mask when grinding and using sandarac.

Ruling up

When a piece of calligraphy has been developed to a paste-up (see p. 24) or final rough, the next stage is to rule up your paper before starting to write the finished piece. There are three different ways of ruling up, all of which require a sharp HB, H or B pencil. The measurements should be marked on both the left and right margins. The three methods are:

1. Use a ruler with clear markings to measure the height of the letters and interlinear spacing, and transfer the marks to the paper.

2. Mark the letter heights and interlinear spacing on a separate sheet of paper and use these measurements as a guide to marking the paper for the finished piece.

3. Set a pair of springbow dividers to the distance between one top line of writing and the top line below it and 'walk' the dividers down the sides of the page. The points of the dividers will mark the paper. Then, repeat the process for the base lines.

For all three methods, use a pencil and ruler to join the marks accurately to make parallel lines.

Before you start to write

Always double check your measurements after ruling up. Some calligraphers rule up two or three sheets in case they make mistakes, or so that they can work on two or three finished pieces and choose the best one. Ensure that all the materials you will need are to hand. Begin by writing on a spare sheet of your paper before starting on the finished piece. This will relax your hand and help you to become accustomed to writing on your chosen surface.

Make sure you have enough time to write the whole piece – or a particular part of a piece – in one sitting. If you interrupt your work your writing may end up looking inconsistent. Although a large panel of work may take far too long to do in one sitting, different parts can be done at different times. If you are working on a manuscript book with a lot of text pages, write each pair of pages in one sitting, so that the writing remains consistent on each spread.

Making a mock deckled edge

1 Score a line where the edge of the piece is to be. Using a clean paint brush, brush water onto and slightly beyond either side of the score line. You may need to do this more than once in order to ensure that the fibres around the score line have been softened.

2 Pull the paper apart along the wet score line. Pull the sides directly away from each other using the same amount of force for both sides. The edge of the paper will dry slightly puckered and rough, almost like a true deckled edge.

3 Do not hold one side and pull the other up at an angle in the usual way of tearing paper. The fibres should pull out at right angles to the edge when the paper has been torn apart.

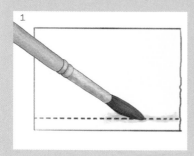

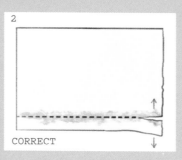

CORRECT

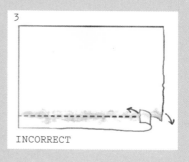

INCORRECT

Erasing mistakes

Every calligrapher knows the despair that comes from making a mistake when writing a finished piece. But it is not always necessary to write the whole piece again; mistakes can often be erased with time and care. It is always best to practise first, using a piece of the same paper. This will show you how the paper behaves, whether it discolours and if the erased surface can be written on again.

Using a scalpel
Scrape the ink very gently off the surface of the mistake with a sharp scalpel. Do not dig into the paper or vellum. Remove the resulting fine dust of ink using a tissue, or by gently rubbing with a soft pencil eraser. When you are unable to scrape off any more ink without cutting into the surface, continue rubbing gently. Disturb the fibres of the paper as little as possible. When all the ink is removed, flatten the fibres by rubbing the area with the flat edge of a bone folder or the flat of a fingernail. If you are doing a trial erasure, this is the stage to find out whether the surface you are using can be written on again. Use as little ink on the nib as possible when re-writing, to avoid bleeding. If bleeding does occur, try dusting the surface with a little finely ground sandarac before writing again.

Using an eraser
Some soft papers cannot be easily scraped with a scalpel and it is best to use an eraser. A small piece of ink eraser held between tweezers or the prongs of a ruling pen can be used to rub small, specific areas. A 'pencil' typewriter eraser can be good for this purpose. Be sure to rub slowly and carefully. With time and practice, you will eventually find the best way of erasing mistakes depending on your touch and the paper surface.

Easing the tension

Most calligraphers find making a finished piece nerve-racking. The final rough may have gone well, but tension still mounts with the prospect of having to do the finished piece. This tension tends to show in the lettering – which further impedes the fluency and freedom of the writing.

Every calligrapher finds their own way of dealing with this problem. Some find that background music takes away the intensity of the silence needed for concentration, others find that working on more than one version of the finished piece helps them.

CLASSIC

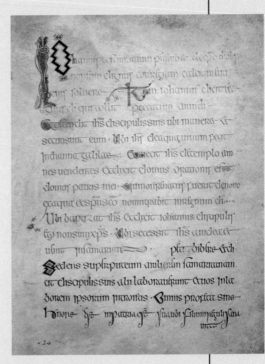

CALLIGRAPHY

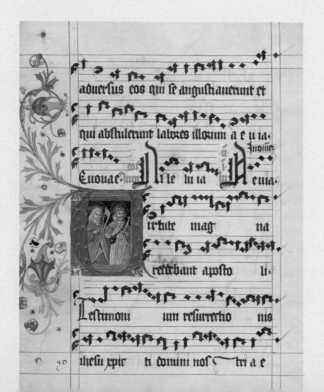

Classical Latin script originated in Ancient Rome, and Roman capitals were used for stone inscriptions, painted lettering and luxurious manuscripts. After the decline of the Roman Empire, handwriting was preserved in *scriptoria* – 'places for writing' – which were attached to Christian monasteries across Europe. Writing was hard work: scribblings in the margins of medieval books record the cold, the monks' cramped hands, bad backs and strained eyesight, badly made batches of ink and hairy parchment.

Facing page, top: Page from the Book of Kells, c. 800, Trinity College Dublin MS 58, f. 24r

Facing page, bottom: Petrarch, *Sonnets and Triumphs* (detail), c. 1463-4, Padua, 23 x 14 cm (9⅛ x 5½ in.), National Art Library, V&A: MSL/1947/101, f. 162r

Above: Edward Johnston, calligraphy sample, c. 1902-3, London, 32.6 x 41.2 cm (12⅞ x 16¼ in.), V&A: E.1008-1945, Given by Miss S. C. Harding

Left: Leaf from an Antiphoner, c. 1490, Mainz, written area 35 x 22.8 cm (13⅞ x 9 in.), V&A: 1107:3

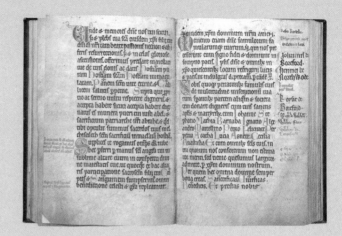

As books were copied and copied again, a number of separate but related scripts developed – one such was the regular, readable 'insular' script found in manuscripts copied in the British Isles from about the 7th century onwards. Examples include the elaborate Book of Kells, which contains the Latin Vulgate Gospels and was copied by four scribes in a clear, bold insular majuscule. It is usually traced to the monastic community of St. Columba, which by c. 800, when the manuscript was likely copied, was based in Iona, Western Scotland, and Kells, Ireland.

The clarity of insular scripts had an influence on Carolingian minuscule, a script developed partly under the patronage of the Holy Roman Emperor Charlemagne in the late 8th century. Though not fully literate himself, Charlemagne was passionate about literacy and understood the power of a uniform, highly legible script when it came to running an empire. Over 7,000 manuscripts survive in the Carolingian hand, including books of classical literature that would otherwise have been completely lost.

Carolingian minuscule was ultimately superseded by Gothic script, also known as blackletter because of the dense, black pages it produced. Its higher words-per-page count made it an economical choice, and a Gothic typeface called Textualis was used for the first Western manuscript printed using movable type, the Gutenberg Bible, in 1454–5. The greater readability of Carolingian minuscule, however, meant that when the Humanists of the Italian Renaissance came to develop beautiful, legible handwriting, they looked back for inspiration to the script they called *littera antiqua*. Humanist, or Italic, minuscule and the related neat, sloping Italic cursive were used for copying the classical and humanist texts that had been preserved centuries before under Carolingian rule; the writing style was intended to reflect the contents.

Another renaissance – this time of handwriting itself – also took inspiration from Carolingian minuscule. In the early 20th century, the British designer, calligrapher and teacher Edward Johnston developed a script that he called the Foundational hand. It was based on the writing of the Ramsey Psalter, which was copied in England in the last quarter of the 10th century using a particularly elegant Carolingian minuscule. The simplicity and beauty of the Foundational hand has ensured its enduring popularity, and it is often among the first scripts learned by beginner calligraphers today.

Above: The 'Lesnes' Missal, c. 1200-20, possibly Oxford, Great Britain, 32 x 22.5 cm (12⅝ x 8⅞ in.), National Art Library, V&A: MSL/1916/404, ff. 81v-82r

Left: Leaf from a Book of Hours, 15th century, France, (closed mount) 13.9 x 19.9 cm (5½ x 7⅞ in.) V&A: D.1341B-1897

ROMAN CAPITALS

Cast of Trajan's Column, *c.* 1864

In the 19th century, copies of historic lettering such as this plaster cast of the pedestal that supports Trajan's Column – a 1st-century, 35 m (115 ft) Doric column erected to celebrate the military achievements of the Roman Emperor Trajan – encouraged designers to develop new, classically inspired typefaces for the burgeoning print and advertising industries. The inscription on the base of Trajan's Column offers a model for 19 letters. In the early 20th century it was held up as a standard for classical lettering: Brucciani and Co., a London-based plaster casting firm, sold copies of the lettering for £7 a panel, and many schools of art used these as teaching aids. Still considered one of the best examples of the balanced proportions and clarity of Roman capitals, the Trajan letterforms have been widely copied, re-used and celebrated.

Plaster cast of Trajan's Column by Monsieur Oudry, Paris, V&A: REPRO.1864-128. Opposite page: Inscription on the base of the cast of Trajan's Column. Image courtesy of Carlos Jimenez.

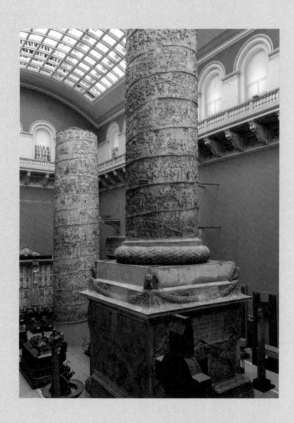

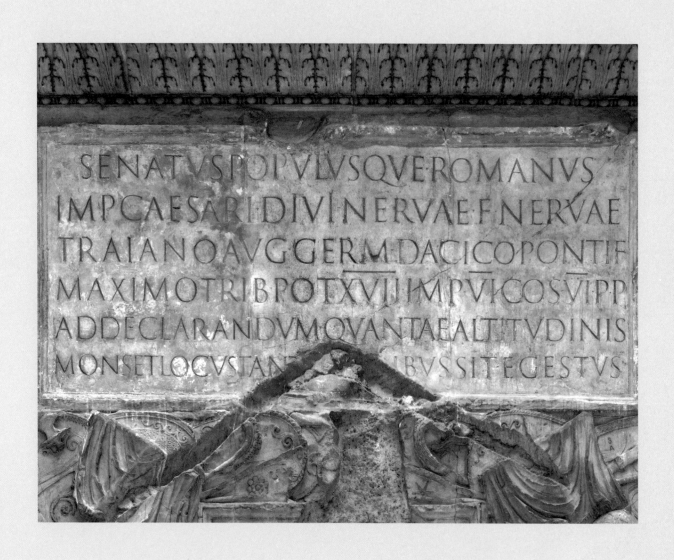

ROMAN CAPITALS

Like all written pen capitals, Roman capitals are based on skeleton capitals (see pp. 18-21) – a relationship that becomes clear when a double pencil is used for writing.

The first step towards writing Roman capitals is to practise with a double pencil. This is a useful exercise that will help you to understand the movement of a pen and the form of written Roman capitals. Each side of a broad nib will make the same lines as the pencil points; the only difference will be that the nib will produce a solid ink line while the double pencil creates two lines with space between them. It is worthwhile keeping your double pencil close to hand so that you can use it whenever you want to check how you are making a letter in relation to its skeleton form.

Making a double pencil

1. Take two HB or harder pencils and shave down one side of each of them, so that they sit with their points closely together.

2. Bind the pencils tightly together with elastic bands or tape.

3. You can keep the points level, or if you are left-handed, slope them to the left. If you are right-handed you could try sloping them to the right. Always keep the pencil points sharp.

Using a double pencil

1. Draw a pencil line across your page. Then draw another, parallel, line above it at a distance that is six times the width of the pencil points.

2. Hold the pencil so that its points are at an angle of 30 degrees to the writing line. The pencil points are equivalent to the sides of a pen nib.

3. Try writing an H shape first, then an O shape in two strokes. Each pencil point makes a skeleton letter (see p. 20). All your letters are made up of two overlapping or parallel skeletons, set apart at the angle at which you are holding your double pencil.

4. To examine the shapes of the letters, join the skeleton lines together within each letter and colour between them with a crayon or pencil. This will help you to see the forms of the Roman capitals as well as the lines of the skeleton shapes.

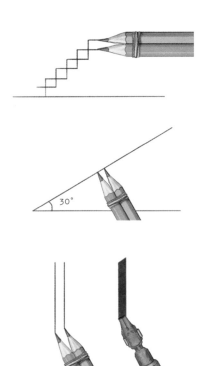

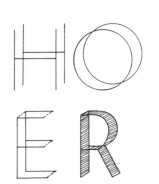

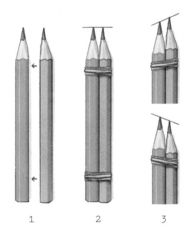

1 2 3

Pen angle and weight

Draw a baseline across your page, then use a wide nib to mark six nib widths up from this line. Measure the six nib width height with a ruler and make pencil marks or pin pricks down both sides of the page. Join the marks or pin pricks using a ruler and pencil.

When writing, hold your pen at a 30 degree angle to the writing line, to maintain a contrast between thick and thin strokes.

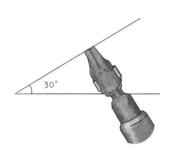

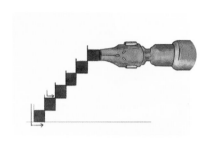

Family groups

The diagrams below show the 'family' likenesses between various groups of letters, and their individual pen strokes. Two points are particularly important while you are writing: the shapes of the strokes as you complete the letters, and the white spaces around the strokes and letters. The consistency of the spaces is as important as the shapes and direction of the pen strokes.

Round letters: O, Q, C, G, D
The top and bottom of O and Q can very slightly cut the writing lines, so that they appear to be the same height as the other letters. Make sure that D is wide enough, and flatten the tops of C and G to carry the eye to the next letters.

Rectangular letters: H, U, T, Z
Sit the crossbar of H just above the centre. Try and keep the crossbar of the T fairly lightweight. Flatten the pen angle completely for the centre stroke of Z, to add more weight than if the angle was 30 degrees.

Narrow letters: I, J, L, E, F, K
The bottom curve of J can be flat, or it can stop just below the line. The crossbars of E and F are the same length, but the crossbar of F is slightly lower than the middle crossbar of E, to balance the white

space. The bottom crossbars of E and L are slightly longer than the upper ones. The second stroke of K should only just touch the first stroke.

Diagonal letters: A, V, X, Y, N, M, W
Steepen the pen angle to give a good contrast between thick and thin strokes for these letters – it can be held at approximately 40–45 degrees, but try to flatten the angle slightly for the thin strokes.

Small bowl letters: B, P, R, S
The arms of S are flattened curves that do not cut into the bowl shapes. Take care to make the internal spaces rounded – check the inner shapes of the bowls when writing P, B and R.

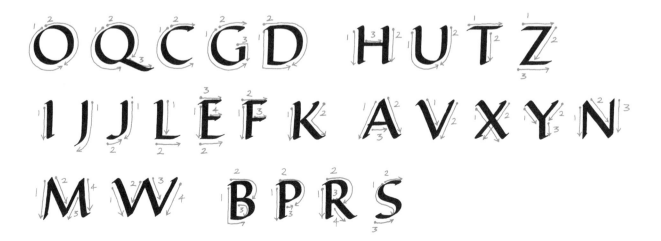

Common mistakes

1. The ends of both strokes of C curl up and down too much.

2. The pen angle has not been flattened for the centre stroke of Z, so the letter looks too light.

3. The legs of M are splayed out rather than straight.

4. The second stroke of K cuts into the first stroke, so the middle of the letter looks heavy.

5. The arms of S cut into the bowl.

6. The bowl of R slopes as it moves to join the upright – it should be kept horizontal.

7. There is too much contrast between the thick and thin strokes on the X. Flatten the pen a little for the thick stroke.

C Z M
K S R X

Numerals and punctuation

Numerals are written at the same height and weight as letters – six nib widths. Their bowls are round, to echo the letterforms. A question mark has a small curl underneath the upper curve. Twist the pen as it moves down for an exclamation mark, and try to keep your commas and inverted commas small and curved.

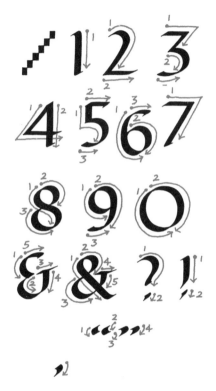

Spacing

Roman capitals are spaced by eye, so there are no set rules, only basic guidelines. A helpful way to check spacing is to look at three letters at a time (see page 21.)

Even spacing
Areas between letters must be visually equal, both with each other and the space inside the letters.

Approximately one O-sized space separates words, to ensure that they are read separately but that the flow of reading is retained.

Wide spacing
If letters are written too far apart, they will not connect visually to make words. The eye will not flow easily along the word or line and reading will be slowed down as a result.

Close spacing
If letters are too close, dark patches will form and the O forms will look like holes in the lines of text. The texture of the page will be uneven and legibility may be impaired.

How to check spacing
A useful check is to look back at your work with your eyes half-closed and out of focus, so that you are looking at the piece as a whole without concentrating on reading. Spaces that are too close will appear as dark patches in your work. There should be an even pattern of black and white, stroke and space.

EVENLY SPACED
WIDE SPACING
MUCH TOO CLOSE

Practice alphabet

Begin to practise your Roman capitals. Use a wide nib so that you can clearly see the shapes you are making. Start by copying the letters in their family groups, to get a feel for how their shapes relate to each other. Try to spot and correct any bad forms as you work.

When you are writing confidently, use the letters to write out single words or a quotation – this will help you to practise the letter shapes and spacing at the same time. You could also begin to write letters at different weights and sizes. You can do this by altering the number of nib widths in the height of the letters, or by changing the size of your nib.

ABCDEFG
HIJKLMNO
PQRSTUV
WXYZ

WALL HANGING

Roman capitals are especially suitable for writing out titles and important statements. This banner shows a Latin proverb, *VERBA VOLANT SCRIPTA MANENT* ('spoken words fly away, written words remain'), written using a home-made balsa wood pen, which gives an interesting texture to the lettering.

Project by Susan Hufton

You will need

2 or more sheets A3 cartridge paper, 140 gsm/95 lbs (for practising)

2 sheets good quality A3 paper, min. 300 gsm/140 lbs (here, a heavy cream Somerset paper is used)

2H pencil

Metre (3' 3⅜ in.) ruler with metal edge

Small pieces of balsa wood (a large chopstick, an 8 mm (⅜ in.) flat nib or an automatic pen - see p. 12 - would also be suitable)

Bottled or freshly ground stick ink, or gouache or watercolour paints in 2 colours

Craft knife or scalpel

Cutting mat

Glue stick or PVA glue

Length of dowel or bamboo cane, approx. 50 cm (19¾ in.) long and 8 mm (⅜ in.) diameter (available from DIY or garden supply shops)

2 large L-shaped pieces of card (see p. 25; for determining margins)

Paint for dowel (optional)

Nails and hammer, for hanging (optional)

Thread, cord or ribbon, for hanging (optional)

VERBA
SCRIPTA

How to make

Practise the text on pieces of ruled-up layout paper until you are happy with your writing.

1 First, make a balsa wood pen. Using a craft knife, carefully cut one edge of a piece of balsa wood at a 45 degree angle to create the flat 'nib'. Cut the pen to size if needed - here, the nib width is 8 mm (⅜ in.). Balsa wood pens become blunt quite quickly, so you may wish to make several. You will need at least one for each colour of ink that you are using.
Tip: *You could use a piece of thick card cut in the same way. Chopsticks also make a useful tool, with one end flat like a wide nib, the other with two points to make parallel lines. These tools do not hold ink as long as a metal nib, and so the ink drags out to make interesting marks.*

2 Decide how large you would like your finished banner to be. The one shown here is 27.8 x 42 cm (11 x 16⅝ in.) including the finished tab height. Remember that you will need to leave room at the top for your tabs - here, the tabs are 6.8 cm (2¾ in.) from the top margin to the cut edge. Decide on the phrase that you are going to write out on your banner. The one here is Latin: *VERBA VOLANT SCRIPTA MANENT* ('spoken words fly away, written words remain'), but you can choose anything you like.

3 Establish the height of your letters. On your practice sheets, draw out guidelines with a pencil and metal ruler and practise the text several times to see how much space the words take up along the line.

4 Decide on the margins by laying two large L-shaped pieces of card around the edges of your practice lettering and moving them until you are happy. In this project, there is 5 cm (2 in.) of space above the top line of writing and 6 cm (2⅜ in.) space below the bottom line. See p. 25 for more on choosing margins.

5 Using the balsa wood pen dipped in your chosen paints or inks, experiment until you are familiar with how it feels to write the letters, happy with how you are making the shapes and know where the letters are going to be positioned. Roman capitals have no ascenders and descenders; there are no strokes that go above or below the body of the letters, so you can try the lines close together or with a little space between them to discover which you prefer. In the project shown, the base and top lines are 4.8 cm (2 in.) apart, with 5 mm (¼ in.) between each line of capitals.

6 Once you are happy with your practice piece, measure it carefully and rule up a piece of the same paper you will use for your final work, leaving plenty of space around the text area for the margins. Remember to leave room at the top for the tabs.

7 Write out your chosen phrase on the ruled paper and add some simple decorations with the pen; these can be triangle or diamond shapes. Tweak the design a little, if you like: you may find that the letters need more or less space, or the margins need to be a little larger or smaller.

8 Rule up the sheet of paper for your finished piece, indicating clearly where the tabs should be cut out.

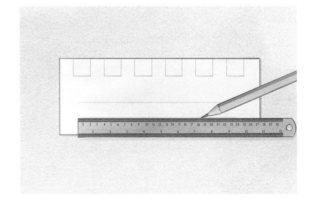

9 Carefully write out your final piece and add the decorations. Leave the ink to dry between adding the black lettering and coloured decoration. It is very easy to smudge ink that isn't quite dry.

10 Once the ink is dry, check and cut your side and bottom margins. Then, cut out your tabs: first, using a craft knife, prick holes at the right angles where the cut edges will meet. This will give your knife an exact place to start cutting, and will stop the tab cuts from tearing. Carefully make the cuts for the tabs with the knife and metal ruler.

11 Bend the tabs to the back of your piece, but don't crease them. Glue them into position, leaving enough open space for the dowel to thread through. Leave the glue to dry.

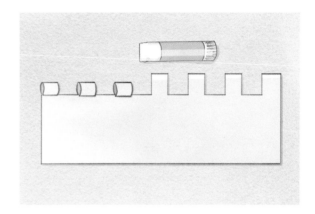

Cut out your tabs carefully, using a craft knife and metal ruler to give a clean edge.

Once your dowel is painted and cut to size, thread it through the tabs to finish your piece.

12 Cut the dowel to size if necessary, depending on how much you think it should protrude beyond the hanging. You could also paint it to match the text decoration. Leave it to dry before threading the dowel through the tabs.

13 To hang your piece, knock two nails into the wall to support the pole at either end, or use thread, cord or ribbon to hang it from a hook.

Now try...

Choosing another text, or writing out an alphabet with the letters and words sitting on top of each other to make a vertical layout, with or without space between lines, for example:

ABC
DEF
GHI

This will make a vertical hanging, which you can finish in the same way as the project above. You could make tabs at the bottom too, and thread another dowel through them so that your piece hangs with some added weight.

It is also possible to write with a balsa wood pen onto heavy calico cloth, so you could make a fabric hanging instead of using paper. If you don't want to draw guidelines onto the cloth, you can sew them with a loose running stitch and pull the stitches out afterwards.

FOUNDATIONAL HAND

Sion Gospels, c. 1125-50

Carolingian minuscule, the book hand used in this 12th century manuscript, was the standard script used across Europe between around 800 AD and 1200 AD. It was created in proximity to the court of the Holy Roman Emperor Charlemagne, who was passionate about literacy and culture and promoted the use of a uniform and easily legible script for the administration of his vast empire.

The writing in this manuscript is a particularly beautiful example of Carolingian minuscule. The letters are rounded, with easily distinguishable capital letters and clear spacing. Initials and headings are in red. The text was probably written in what is now Switzerland, perhaps in the diocese of Sion. It records, among other liturgical texts, the sections of the Gospels which were read at mass during the main church feasts of the year.

Ink and colour on parchment, Switzerland, 188 ff., 25 x 23 cm (9⅞ x 9⅛ in.), with a loose sheet of 19th-century parchment (a notarial document), V&A: 567–1893, ff. 163v – 164r (below) and f. 152r (opposite page)

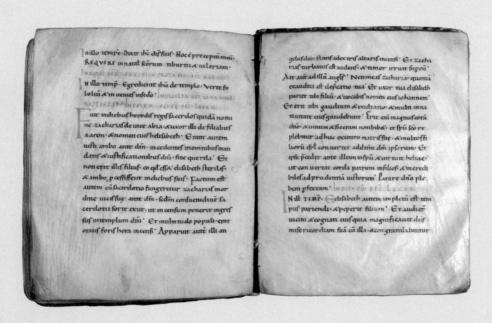

tum quisque negociatus esset · Venit aut primus
dicens · Dñe · mna tua · decē mnas adquisiuit · Et
ait illi · Euge bone serue · quia in modico fidelis
fuisti · eris potestatē habens supra decē ciuitates ·
Et alter uenit dicens · Dñe · mna tua · fecit quinq ·
mnas · Et huic ait · Et tu esto sup quinq · ciuitates ·
Et alter uenit dicens · Dñe · ecce mna tua · quiā ha
bui insudario · Timui enim te quia homo auste
ris es · tollis qd ñ posuisti · & metis qd ñ seminasti ·
Dixit ei · Deore tuo te iudico · Serue nequā · sciebas
quia ego aus teris homo sum · tollens qd non posui · & me
tens quod non seminaui · Et quare non dedisti pecuniā
admensam · et ego ueniens cum usuris itique exigissem
illud · Et asstantibus dixit · Auferte abillo mnam · &
date illi qui decem mnas habet · Et dixerunt illi Dñe ·
habet decem mnas · Dico autē uobis · quia omni haben
ti dabitur · & habundabit · Ab eo aut qui non habet ·
& quod habet auferetur abeo · Veruntamen inimicos

FOUNDATIONAL LETTERFORMS

The Foundational hand is based on the Carolingian minuscule script of the Ramsey Psalter (British Library, Harley MS 2904), shown opposite, which was written in the south of Britain towards the end of the 10th century. The manuscript is clearly and beautifully written, with remarkably well-made, consistent letterforms. Most of the letters are based on the circle, and as a result they are closely interrelated.

The Ramsey Psalter is a good starting point for learning minuscule letters. Its letterforms have strong similarities to the forms of Roman capitals, and can therefore be used with them.

Edward Johnston encouraged his students to study manuscripts as he himself had done, and to analyse their various elements. The clarity of the psalter means that it is a useful example to look at when learning how to analyse a manuscript in order to develop a modern script.

Learning from a manuscript is not a matter of just copying the letters. In order to be able to form the letters with consistency and understanding, it is necessary to ask questions about what you see in relation to the tool used – in this case a broad-edged pen – and the size and weights of the letters. As you study a manuscript, ask yourself the following questions, based on Johnston's seven points for the analysis of historical scripts. Answer them by eye, and make sure you have a pen to hand with which to make trials.

- What is the pen angle used and is it consistent or not? If not, how does it change?

- What nib width has been used? If looking at an enlargement or reduction, which nib could be used to make a same-size study?

- What is the height of the letter in relation to the width of the pen stroke?

- Are the letters upright, or by how much do they slope?

- What is the shape of the o and how does it relate to other letters?

- Are there any other particular characteristics such as serifs, joins, spaces?

- What is the stroke sequence – how are the letters made?

- Are any changes necessary for contemporary use, e.g. additional letterforms?

Basic principles

Today's calligraphers impose more of a sense of family likeness on the Foundational hand than the scribe who wrote the Ramsey Psalter, in part because readers used to printed text have become accustomed to seeing equal x-heights. The Foundational hand is always written with a square-edged writing tool. Five basic principles underlie Foundational:

- The pen angle is 30 degrees.
- The o is a circle.
- The curves in the letterforms echo the o.
- There are equal areas of white space inside the letters.
- The top third of the x-height is emphasized.

These guidelines enabled the writing of a thousand years ago to be updated to make a beautiful modern alphabet. Carolingian minuscule did not use capitals in the way they are now used. Today, we use Roman capitals (see p. 34) at the start of all sentences and for names.

Opposite page: Beginning of Psalm 51 (50), the Ramsey Psalter, 10th century, Great Britain, 33.5 x 25 cm (13¼ x 9⅞ in.), British Library, Harley MS 2904, f. 61v.

matris tuę ponebas scandalum .

haec fecisti & tacui . : . :

xisti mafti iniq. quod ero tui similis .

arguam te & statuam

contra faciem tuam . :

ntelligite haec qui obliuiscimini

dm . Hequando rapiat

& non sit qui eripiat . : .

acrificium laudis honorificabit

me . & illic iter quo ostendam

illi salutare dei . INFINEM psalm

DAVID CV VENIT AD EVM NATHAN PRO

PHETA . CV INTRAVIT AD BETSABEE .

Miserere mei ds . secundū magnā

misericordiam tuam : . : . :

t : secundū multitudinem misera

tionū tuarū . dele iniquitatē meā : .

mplius laua me ab iniquitate

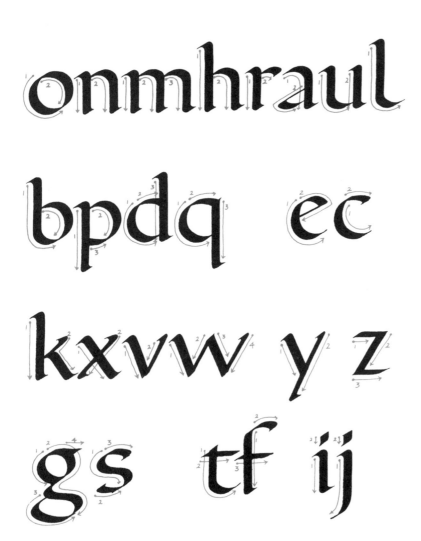

Ungrouped letters: g, s, t, f, i, j
The round part of g is smaller than o, so that there is enough room for its tail. This makes it a bit narrow at the top, so a small 'ear' is added, running along the reading line, to keep the eye on the top third of the letter. The bottom bowl should be wide, to enclose a lot of white space, or it will look like a black blob and draw the eye downwards.

The crossbar of t sits immediately below, but touching, the top line. The crossbar of f can be slightly lower, so that the enclosed area of white space at the top of the letter balances with the white space below the crossbar.

Historically i and j are the same letter; the longer form (j) was used as the last digit in Roman numerals in order to prevent fraud – for example, vjj is seven, viij is eight.

Take care to keep the pen angle consistent. For example, a tendency to steepen the pen angle for the crossbars of t and f will reduce the beautiful, characteristic contrast of their thinness with the thickness of the verticals.

Family groups

Arched letters: o, n, m, h, r, a, u, l
The top of m is flatter than the top of n, so that the second arch also has strong junctions. Both h and m have the same inside shapes under the arches as the inside of o. The top of a is the same as the second part of n, and the thin stroke of its bowl enters the letter halfway up the body height.

Round letters: b, p, d, q, e, c
The first stroke of the b is like an l. The bottom curve of p and the top of d and q do not follow the circle.

e and c do not have right-hand sides, so their curved backs are slightly straightened to prevent them seeming to fall over backwards.

Angled letters: k, x, v, w, y, z
v, w and y are all slightly wider than n. Normally, the uprights of a letter are about ⅞ of a nib width thick and the thin crossbars are a ½ nib width thick, but the thick strokes in the v group should be closer to 1 nib width thick and the thin strokes thinner than a ½ nib width.

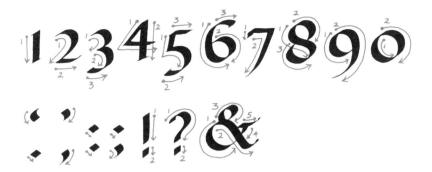

Numerals and punctuation

The 0 should echo the letter o, and the curves of 2 and 3 also follow this shape. The 1 has small serifs. The 4 can be made with a slightly tight triangular bowl in small writing, because the thin diagonal tends to have only a small visual impact. The white spaces in 5 are balanced, the lower curve echoing the 3. The 6 and 9 are mirror images of each other, except that while the tail of 9 can be flicked around, the top of 6 cannot be made with such a quick pen movement. The small vertical serif at the top of 7 can be missed out if preferred. The central thin strokes of 8 are offset, unlike the Roman capital numerals (see p. 38), because the smaller bowls would otherwise become quite tight.

Full stops and commas are placed very close to words. Colons and semi-colons are the height of an x. The dot under question and exclamation marks echoes their movement, and is not angled like a full stop. The ampersand (its form originating in the Latin *et* for 'and') is copied from the Ramsey Psalter.

Practice alphabet

Start to practise your Foundational hand using a wide nib, so that you can see the letterforms clearly. First write the letters out in their family groups and, as you gain confidence, begin to write words and phrases.

Remember that Foundational hand is an adaptation of a historical script – the characteristics of your Foundational hand may be slightly different than those shown below, based on your own analysis of the Carolingian minuscule hand – though your writing should follow the same basic principles (see p. 48).

abcdefghijklmn

opqrstuvwxyz

Starting to write Foundational

The best way to prepare for writing Foundational is to first look closely at the Ramsey Psalter on p. 49. Notice how the top serifs of the letterstrokes are bigger than those at the bottom. This is partly due to the action of the pen spreading the ink to the whole writing edge as it begins the stroke. But these larger top serifs also help to hold the eye at the reading line – the top third of the x- height. The writing of the Ramsey Psalter and the alphabet on p. 51 also show how close together the letters within a word can be placed. The aim is to have regular, even spacing.

Write your letters at a height of 4 nib widths, like the lettering on the previous page. Look carefully at the skeleton minuscules on p. 22. A strong Foundational hand always shows a clear circular movement in the o and strong arches, which start to thicken as soon as they leave the left-hand vertical strokes.

Foundational hand originated as a 'book hand', and, since page after page had to be read, everything was sacrificed in favour of legibility. Though quicker than Roman capitals, it can be slow to write, since in a typical letter – e.g. n – the pen has to be lifted off the page at the bottom of the letterstroke and put back on the page at the top of the stroke for the second part of the letter. But this also lends the script its great strength, which lies in its steady, rhythmic emphasis on the reading line.

A thorough understanding of the letter shapes and their relationships (see p. 50), and of how the pen makes the forms, is necessary for writing Foundational successfully. Once you have spent some time practising your writing, it is worthwhile going back to the Ramsey Psalter on p. 49. If you look at the word *multitudinem*, three lines up from the bottom, you will realize that it shows elements of the script that you will begin to see in your own writing. The eye is carried along the tops of m, the two ts and d, the n and m; there is a strong rhythmic feel to the bottom of u, l, t, u, d and e. The white spaces inside the letters are evenly balanced. The final serif of one letter leads into the next letter. Letter strokes overlap without hairlines.

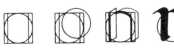

Skeleton forms

The relationship between Foundational letters and the skeletons on p. 22 is similar to the relationship between written Roman capitals and their skeletons. Notice the similar proportions, especially the width of n, which has a skeleton ¾ the width of the skeleton o.

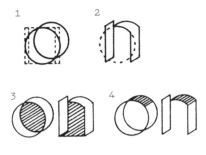

Related forms and areas

If a square is drawn around one of the double circles of o (1) it shows that the crossover points of the two circles occur about ⅛ of the square in from the sides This shows where the legs of n go (2). Both o and n contain equal areas of white space (3) and the curved part of n echoes the curve of o (4).

Serifs and arches

The ink arrives at the writing edge of a pen nib by flowing along the slit, so until the ink is rubbed all the way along the writing edge it lies only at the middle of the nib.

The first movement of the pen on the page is a quick up-and-down sliding movement along the 'skating' thin edge (1). This gives us the larger lead-in serif. The eye reads the top third of the x-height in a letter, and the top serifs are therefore more emphasized than the bottom ones (2), which mostly serve only to terminate the letterstroke. If the bottom serif is too big, it will intrude into the white space of the letter. The last serif in each letter is a bit bigger, and points the eye up to the top third of the next letter (3).

The curve of the arch in n (4) gives a strong stroke at the top of the letter. If the pen makes a hairline, the vital top third will be weakened (5).

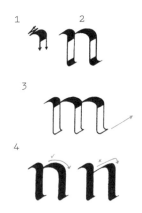

Book margins

When setting the margins for a manuscript book, the considerations to keep in mind are different to those that are involved when a piece of calligraphy is written on a single sheet of paper (see pp. 26–7). There are various kinds of manuscript book:

- A pair of pages, or spread, possibly with a title.
- A single-section booklet consisting of two or more folds of paper, giving four or more pages of writing and illustrations, plus a title page.
- A multi-section book with many pages of writing and illustrations, plus a title page.

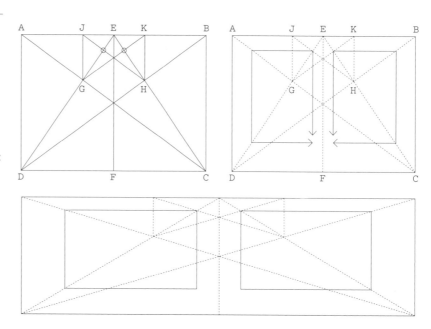

In some books all the pages are very similar, with the writing on each page occupying the same amount of space. The margins and text area are the same for most of the pages. The only exceptions would be the title page, if there is one, and text involving headings or credits. In this case the margins can be set as soon as the approximate page size is decided, and the text is then written within the lines that indicate the text area.

Other books have different amounts of text on each page. In this case each pair of pages, or spread, must be considered individually as well as along with the other spreads to make the book work as a whole, and the margins must be checked visually (see pp. 25–6).

As a general rule, the text that occupies the greatest space sets the margins for the whole book. However, there may have to be an element of compromise.

Traditional book margins are a useful guide. The diagrams above are based on the method devised by Jan Tschichold, a Swiss type designer, and offer a starting point that gives margins similar in proportion to those of traditional books.

The starting points (top left)
The corners of the spread are marked ABCD and either end of the centre-fold is marked EF. Diagonals are drawn AC, BD, ED and EC, and the intersections of these diagonals are marked G and H. Vertical lines are drawn from G and H to the line AB to make points J and K. The diagonal lines JH and KG are drawn. The starting points for making the margins are where these diagonals cross ED and EC (circled).

Setting the margins (top right)
Horizontal lines are drawn left and right from the circles to meet the diagonals AC and BD, then drop down vertically until they meet the diagonals ED and EC. From there,

they are taken horizontally across to meet the vertical lines drawn down from the starting points. The text area can be reduced or increased by choosing any starting point on EG or EH. Using this method, the top margin is roughly half the bottom margin and the centre margins of both pages combined are equal to each side margin. This applies to both horizontal and vertical pages. However, never be afraid to break away from the starting point – the deciding factor is always what the pages look like.

Horizontal pages (above)
The largest margins are at the sides. The top margins look small and may need to be readjusted.

MANUSCRIPT BOOK

Writing continuous text is a valuable way to learn, develop and perfect a chosen script. Book hand has many variations, and here, the regular, beautifully legible Carolingian minuscule writing and clear layout of the Sion Gospels is used as inspiration for writing two pages of a manuscript book in Foundational hand.

Project by Susan Hufton

You will need

5 or more sheets A4 layout paper, min. 45 gsm/31 lbs

2 or more sheets A4 tracing paper

2 sheets B2 (19⅔ x 27⅔ in.) Fabriano 5 paper, 160 gsm/98 lbs

1 sheet A3 coloured paper, min. 300 gsm/ 140 lbs

2H pencil

30 cm (12 in.) ruler with metal edge

Set square

2 pen holders

Number 0, 3 and 4 nibs

Stick ink, black

Gouache paint, min. 1 colour (here, this is matched to the coloured paper)

Craft knife

Cutting mat

Bone folder

Needle and strong thread (ideally, a bookbinding needle and linen thread)

Alice was beginning to get very tired of sitting by her sister on the bank, and of having nothing to do. Once or twice she had peeped into the book her sister was reading, but it had no pictures or conversations in it, "and what is the use of a book," thought Alice, "without pictures or conversations?"

So she was con
own mind [as
could, for the
feel very sleepy
whether the plea
king a daisy-cha
be worth the trou
getting up and pi
daisies, when sudd
White Rabbit with
eyes ran close by her

How to make

Choose a bright paint to complement - or contrast with - your book's cover.

1 Begin looking at the script of the Sion Gospels on pp. 46-7 and the Ramsey Psalter on p. 49, and consider how you would like your interpretation to look. Think about which letterforms make the text particularly readable or beautiful.

2 Photocopy and enlarge the script to a size that you can see, or trace and copy it out with a size 0 nib. Practise writing as much as you like, until you are comfortable with the letterforms and happy with your version of the script. **Note:** *Some of the letters you will need are not used in this Latin manuscript: j, k, v, w, y. Think about how these forms relate to the others which do appear, and look back to the family groups on p. 51 to see how these additional letters might be formed.*

3 As you practise, move from the size 0 nib to the size you wish to use. Practising your writing using the right size nib will help you to make decisions about line length, spacing and how big the finished book might be.

4 When you are comfortable with your writing, begin to design your manuscript pages. Mark out your margins and text space using a pencil and ruler (see pp. 25-6 and p. 53 for guidance on margins) and begin writing out your text - try to use only a baseline rule. Don't worry if the letters vary a little in size as a result - this will lend a natural rhythm to the text. In this project, the text is written using a number 3 nib and the lines are relatively far apart for added legibility.

Tip: *remember to give a decent-sized inner margin, so that your text does not fall into the 'gutter' - the middle of the book. A slightly larger inner margin will appear to be the same size as the outer margin once the book is bound.*

5 For added interest, the capital letters at the beginning of each page are written in bright gouache paint. Experiment with their size and position - think about the capitals in the Sion Gospels, which are known as Versals (see below). To write two little capitals like the A and S shown, first write the letter as a skeleton, then add another parallel stroke to the heavier strokes of the letters. Make the ends of the thin strokes a little thicker, and add tiny serifs. A number 4 nib has been used for these. You could use Roman capitals instead, if you prefer.

Versal letters

The thick strokes of Versal letters are usually made up of three strokes of the pen, and the thin strokes are made with one full-width stroke.

Family groups
Here, the letters are shown with no centre strokes so that their forms can be clearly seen. Thin serifs are added to each completed letter, rather than forming part of a letter stroke.

Straight letters: I, H, L, E, F, J, T
The built-up ends of the E, F, T and L crossbars are made by beginning the second stroke inside the first and curving gently out to thicken its end. This should be a continuous curve.

Diagonal letters: A, V, W, X, Y, Z, M, N, K
The thickening of the ends of the thin strokes is usually built up on the inside of the letter.

Round letters: O, Q, C, G, D
The pen angle can be slightly altered to build up the curved ends on the arms of C and G

Small bowl letters: B, P, R, S
The bowls of B, P and R relate to O. The inside shapes of S are rounded.

U is straight-sided.

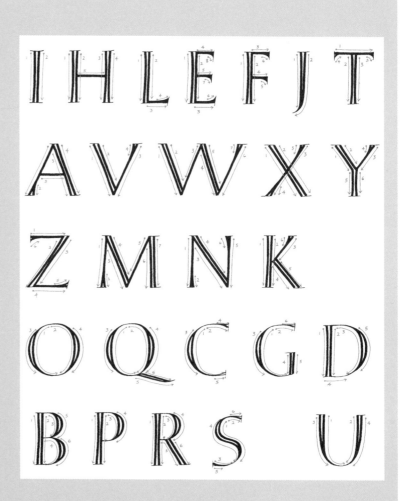

The script on your title page should be larger and heavier than that used for your running text.

6 Try out some different designs for the style of the title, too - this should be given more emphasis than your running text. In this project, it has been written in the same colour as the capitals, but with a number 3 nib.

7 When you are happy with your lettering, turn to your sheets of Fabriano paper. These will need to be folded into equal quarters to make four sheets, which are then cut into pages. Use your bone folder and a metal ruler to make clean folds, and cut only along the top edge (not the spine!). When folded and cut in this way, the grain of the paper should be vertical - this will help the pages to open easily (see p. 27 for how to test the grain).

8 Mark out the margins and text block on one of your newly made pages, making any adjustments as you go. Practise writing out your text on the double page. You may find that adjustments are needed to make the spread look more balanced - tweak your design until you are satisfied with how it looks.

9 Measure out any adjustments you have made to your layout, and carefully rule up your final pages, including the title page.

10 Write out the text slowly and carefully. Give yourself plenty of time, and take breaks if you need them. Add the coloured Versals (see p. 57) once the black ink has dried. Wait until the ink and paint on the inside spread are dry before you write out the title page.

11 When all of your writing is dry, fold the remaining three blank pages of Fabriano paper around your work to make the book-block.

12 Cut your cover from the sheet of coloured paper. It should be slightly bigger than the book-block at the top and bottom, with a wide margin - the 'flaps' - at the fore-edges.

13 Fold the cover around your book-block, using your bone folder and metal ruler to create a straight, clean fold at the spine. Sew the sheets together along the spine using a running stitch. Fold the flaps in over the first and last white sheets, again using the bone folder and metal ruler to create sharp folds.

14 Add some decoration to the cover, if you like - you could write out the title again, or just add some decorative flourishes (see p. 118)

Now try...

Making a book with more pages, using the same method for marking up the margins and lines on consecutive pages. Plan and write the pages in order, adding titles and capitals either as you go along or at the end. Sew the sheets together once all the pages have dried.

GOTHIC SCRIPT

Agostino Hours, *c.* 1470–80

Gothic script began to develop in the mid-12th century in Western Europe, and continued in regular use until the 16th century. It is still occasionally used to lend a 'medieval' feel to official documents. This angular script is characterized by a succession of vertical strokes, forming tall, narrow letters that are often difficult to differentiate from each other. A more legible, rounder form of Gothic script was developed in Italy from the 13th century onwards, and is exemplified in this late-15th-century book of hours.

Books of hours were books of prayers intended for a lay audience. Immensely popular and often lavishly illustrated, they were made in large numbers, especially in the 15th century. In this particular manuscript, the original owner's name, Agostino, is mentioned in one of the prayers to the Virgin.

Ink, gold and colours on parchment, Italy and Flanders?, 7.5 x 5.5 cm (3 x 2¼ in.), National Art Library, V&A: MSL/1923/164, ff. 166v–167r (below) and f. 89v (opposite page)

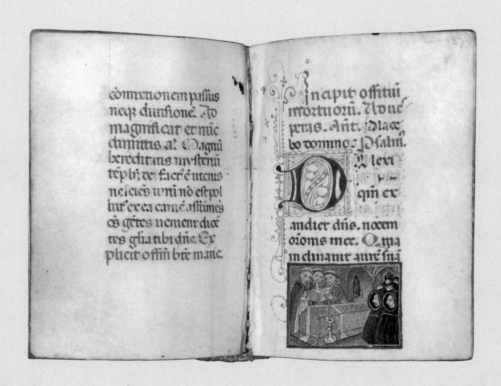

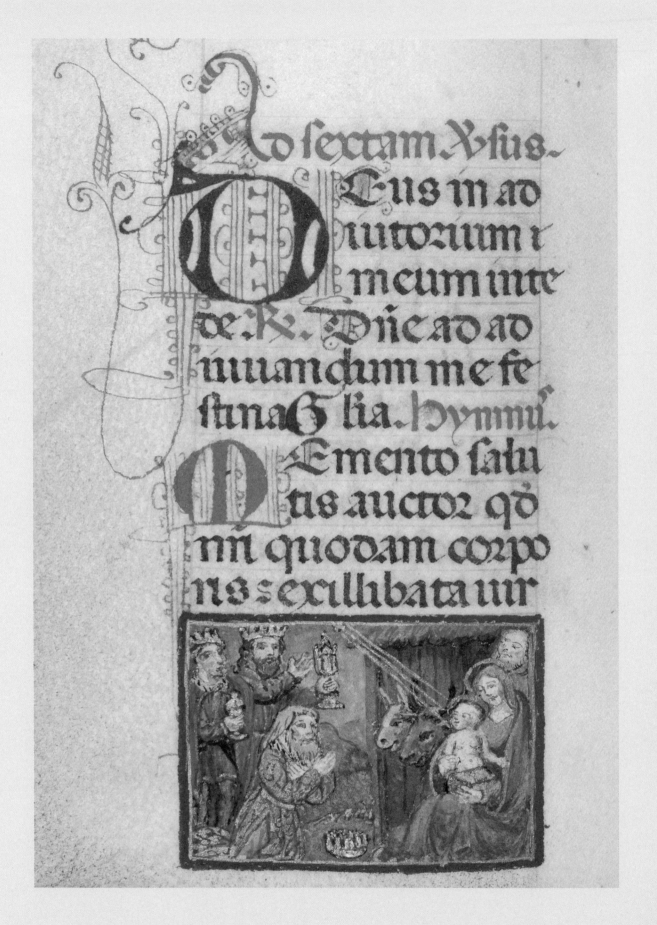

Ad sextam. Psus.
Eus in ad
iutorium t
meum inte
de. R. Dñe ad ad
iuuandum me fe
stina Glia. Hymnu.

Emento salu
tis auctor qd
m quodam corpo
ris ex illibata uir

GOTHIC SCRIPT

Gothic Rotunda is a version of Gothic script which was widely used in Southern Europe, especially Italy and Spain, from the mid-13th century to around the 15th century. It is rounder and easier to read than very early Gothic script.

Rotunda minuscule

Gothic minuscule's key letterforms are n and o. In Rotunda, the rounded form of o is similar to Carolingian minuscule. All other curved letters follow this shape. The n starts with a small diamond and flat termination. The second stroke has a long diamond, and can finish with either a flick or flat termination.

Pen angle and weight
For Gothic minuscule, the pen angle should be about 35–40 degrees. Letters should be about 4 nib widths tall, and ascenders and descenders 1.5–2 nib widths above or below that. Round letters such as o are 1.5 nib widths inside, and straight letters such as n are a little over 1 nib width.

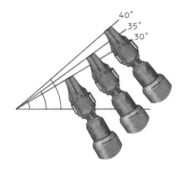

Spacing
Letter spacing in Gothic script is relatively tight – just over 1 nib width – so a word such as 'minimum' should have an even, straight rhythm.

Family groups

Round letters: o, c, e, d, x, s,b, h, p, d, q, g
o provides the basis for these curved letterforms. The two curves of s should make a rounded o. The first stroke of x should be curved like a backwards *c*.

Diamonds: i, j, n, m, r, a, f, u, t, l
These letters all use diamond-shaped strokes of varying lengths. The arches of n and m should be longer and flatter than the first diamond stroke, and the second strokes in r and f should be at a steeper angle.

Diagonals: k, v, w, y, z
A steep diamond stroke should complete the bowls of k and y. The curved parts of v, w, and the first y and z letterforms are all based on o.

Ligatures

The crossbars of f, t and g can continue on to form the first stroke of the next letter. When joined to a downwards stroke such as i, u, or r, the first small diamond is usually omitted. When a letter with a bowl on the right, such as b, p, h or o, is next to a letter with a bowl on the left, such as c, e, o, d, q or s these bowls can overlap. A half-R stroke, shaped like the capital letter without the stem line, may be used after curved letters such as o, p and b.

Numerals and punctuation

Numerals are mostly written at the same pen angle and height as Gothic minuscules. Some numerals, such as 3, 4, 5, 7 and 9, extend very slightly below the x-height, and 6 and 8 start slightly above it. Keep the curves similar to those of the minuscules.

Flat termination

To create the flat termination shown, for example, at the top and bottom of the first stroke of h, either:

Easy: Draw the stem of your letter. At the end of the stroke, shift the pen to 90 degrees from the corner of the stroke and colour in the triangle space between the position of your pen and the letter stem. Or use the corner of the pen to fill in the space.

Hard: Starting with a flat (horizontal) pen angle – 0 degrees – gradually pull the left corner down to change the pen angle to 35–40 degrees. Draw the letter stem and, before the left corner of your stroke reaches the baseline, pull the right corner of your pen down to take the angle back to 0 degrees.

Family groups

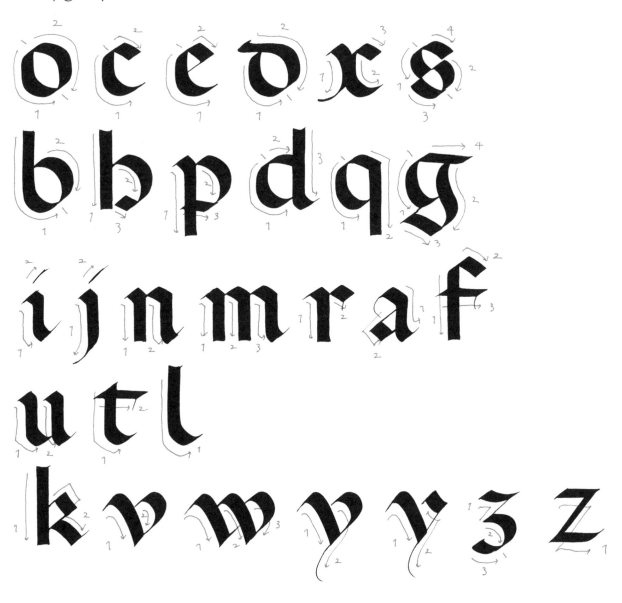

Ligatures

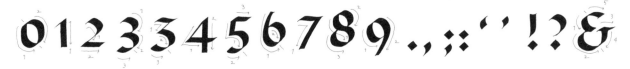

Numerals and punctuation

Rotunda capitals

Gothic capitals are a matter of personal preference; the style shown here is only an example. For more elaborate lettering, draw one or more thin lines parallel to vertical letter strokes, or in the counter-space of letters like O or Q.

Pen angle and weight
The pen angle is about 35–40 degrees, the same as minuscule (p. 62). The letters should be about 6 nib widths high, or minuscule height plus 1.5–2 nib widths.

Family groups

O letters: O, Q, C, E, D, G
O is about 4–5 nibs in width; the decorative finish is optional.

Curved letters: H, M, P, R, S, X
H starts slightly above the capital height and P extends below the baseline. A short diamond stroke connects the two curved strokes of S. The right side of X should be the shape of a minuscule c.

Curved stems: B, F, L, T, A
The stem of F can repeat the curved shape twice, for a decorative look.

Straight letters: I, J, K, N, U
Each letter starts with a small diamond or similar decoration.

Diagonal letters: V, W, Y, Z, A
These should all be written at the same pen angle.

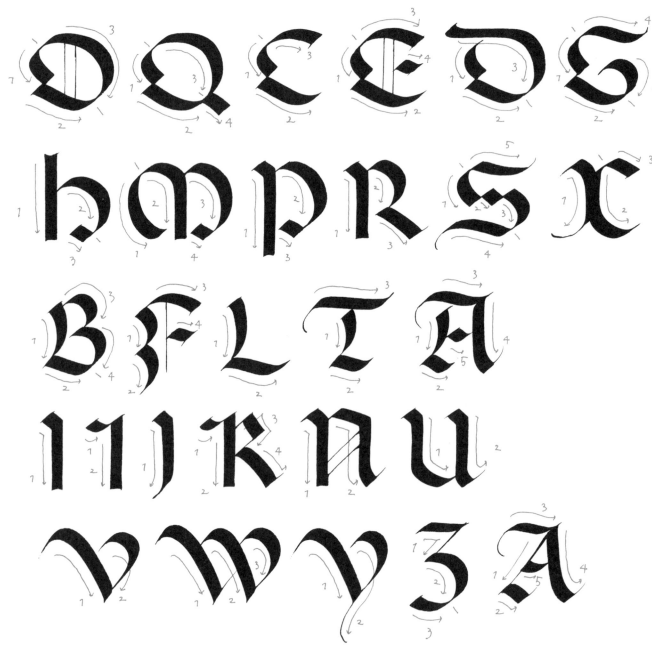

Practice alphabet

Practise the letters using a wide nib. Write them out in their family groups at first, then begin to write short words and phrases, using these alphabets as guides.

Make sure to practise capitals alongside minuscules; this script was designed to be used with a mixture of lower- and uppercase letterforms.

abcdefghi
jklmnopqr
stuvwxyz

ABCDEFG
HIJKLMNO
PQRSTUV
WXYZ

'EX LIBRIS' BOOKPLATE

The phrase *Ex libris* ('from the books of...') is repeated to make a square in the centre of this bookplate. The smaller text around the edges could be the book owner's name, or it could be a personal motto or relevant phrase – even a quote from the book, if you like. Using only black ink gives a crisp contrast and draws attention to the shape of the Gothic Rotunda script and the square design.

Project by Emiko Hashiguchi

You will need

2 or more sheets A4 layout paper, min. 45 gsm/31 lbs
1 sheet A4 hot-pressed paper, 120-220 gsm/75-135 lbs
HB pencil
30 cm (12 in.) ruler with metal edge
2 pen holders
Square-edged nibs in at least 2 different sizes (here, Mitchell nib sizes 1½ and 3½ are used)
Ruling pen (optional)
Medium-sized brush (optional, if using ruling pen)
Black ink (stick ink or gouache)
Scissors
Craft knife
Cutting mat
Glue stick or double-sided tape

How to make

Practise writing out your chosen design, adjusting it until you are completely happy with it.

1 Make quick, thumbnail pencil sketches on your layout paper to explore different layout ideas. Be sure to place *Ex libris* prominently in the centre.

2 Once you have a few clear layout ideas, rule a baseline and begin to practise writing out the words using your pen. Write *Ex libris* and your choice of smaller text in several different sizes and weights, to see what works best. You could also try using different styles of lettering for the E and L, writing *ex libris* in minuscule only, or using ligatures (see p. 62-3).

3 Make a paste-up. Scan some of your preferred pieces of lettering and move the words around on the computer, or take a photocopy, cut the words out and try some of your thumbnail layout sketches to see what works best.

4 Write your chosen design out on the layout paper again to make sure that it works, and tweak it as necessary until you are satisfied with how it looks.

5 Measure out your design onto the hot-pressed paper, marking a grid onto the paper in pencil lightly, so that it is easy to remove the pencil marks later. Write *Ex libris* in the centre first, using your larger nib (here, size 1½), then add the smaller text around it, changing to your smaller nib (here, size 3½). Work slowly and carefully. It will help to turn the paper as you work, so that your hand does not smudge the ink.

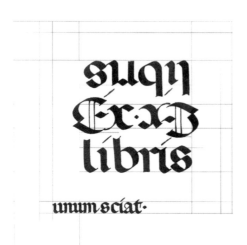

6 Use a ruling pen or fine nib (size 3½ or smaller) to add a border around the edges of your design. If you are using a ruling pen, load ink into it with a brush. Measure an equal distance from the letters and mark the border out with a pencil first. Use a ruler so that you get a nice straight line.

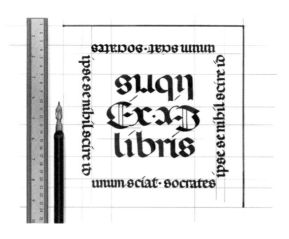

7 Using a craft knife, metal ruler and cutting mat, cut the paper to size a few millimetres outside the border you have made. Carefully erase any visible pencil marks.

8 To affix the bookplate to the inside of a book, use a glue stick or double-sided tape around the edges of the plate.

Now try...

Using coloured ink to add a third layer of text or decoration, inspired by the coloured ink and decorations in the Agostino Hours (see pp. 60–1). You could create an elaborate border, or use colour to emphasize particular text elements. You might use these techniques to create other types of label or greetings cards.

ITALIC SCRIPT

The Sonnets of Pietro Bembo, c. 1550

This manuscript contains poems by the Italian scholar and cleric Pietro Bembo (1470–1547), and is written in a cursive script known today as 'Italic'. The Humanist movement, which originated in Italy in the 14th century, stimulated a rediscovery of the legacy of classical antiquity. This led to the production of numerous copies of early texts and, in the process, to a reform of handwriting. Humanists abandoned the Gothic script and strove to make their manuscripts more legible by adopting clear, regular scripts. The cursive Italic script was developed concurrently with the 'Humanist minuscule' script, and this manuscript showcases the elegance and clarity of Italic. These were the qualities which moved Edward Johnston (1872–1944) to include it in his highly influential calligraphy manual *Writing & Illuminating & Lettering*, published in 1906.

Ink on parchment, Italy, 21.5 x 13.5 cm (8½ x 5⅜ in.), National Art Library, V&A: MSL/1957/1347, f. 64v (below) and f. 1r (opposite page)

Amor; che meco in quest'ombre ti staui.

Amor la tua uirtute.

A questa fredda tema, a questo ardente.

Amor e donne care un uano et fello.

Alma se stata fossi a pieno accorta.

A quai sembianze amor madonna agguaglia.

Anima; che da bei stellanti chiostri

Amor, mia uoglia, el uostro altero sguardo.

Piansi et cantai lo stratio et laspra guerra
 Ch'io hebbi a sostener molti et molt'anni
 Et la cagion di cosi lunghi affanni,
 Cose rado o non mai uedute in terra.

Diue; per cui s'apre Helicona et serra,
 Vo far a la morte illustri inganni,
 Date a lo stil, che nacque de miei danni,
 Viuer, quand'io saro spento et sotterra.

Che potranno talhor gli amanti accorti
 Queste rime leggendo al uan desio
 Ritoglier l'alme col mio duro essempio:

Et quella strada, ch'a buon fine porti,
 Scorger da l'altre; et quanto adorar Dio
 Si debba solo al mondo, ch'è suo tempio.

Io; che di uiuer sciolto haueo pensato
 Quest'anni auanti, e si di ghiaccio armarme,
 Che fiamma non potesse homai scaldarme;
 Inseme auampo, et son preso et legato.

Giuami sol per uia; quando da lato
 Donna scesa dal ciel uidi passarme;
 Et per mirarla posi in terra l'arme,
 Che tenute m'haurian forse campato.

Nacque ne l'alma in tanto un fero ardore,
 Che la consuma; et una mano auinse
 Catene al collo adamantine et salde.

Tal per te sono, et non men pento Amore:
 Pur che tu lei; che si m'accese et strinse;
 Qualche poco Signor leghi et riscalde.

ITALIC SCRIPT

The Italic script developed during the 15th and 16th centuries, at the same time as printers began to replace scribes as the primary makers of books. There are many variations, but all were written quickly, which gives them certain characteristics in common.

It is easier to make rapid up and down movements than wide and round ones, so Italic letterforms are narrow. Because narrow letters contain less white space than wide ones, they are taller to compensate. Italic letters tend to have a forward slope.

Italic hand is one of the most popular hands today, because it is very legible, even when written very small, and has a pleasing fluency to it.

Writing Italic

The key concepts to remember when writing Italic are:

- Letter strokes should appear to be parallel even when one is curved and another is straight.
- Letters should appear to be evenly spaced, with the same distance – not area – between them.
- The eye still reads the top third of the text, so as in the Foundational hand, this part of each letter is emphasized.

Minuscule

Pen angle and weight

An angle of between 30 and 40 degrees keeps the contrast between thick uprights and thin cross-strokes. The angle is often flatter at the top of the letter. The height is 5 nib-widths.

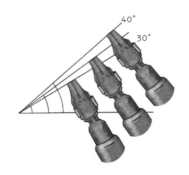

The key letter in Italic minuscule is a. In informal Italic, the a can be written without taking the pen off the page, but for formal writing several pen lifts may be necessary. The straight pen stroke that creates the left-hand stroke of a should almost 'bounce' off the bottom line into a diagonal, which takes it straight to the top right-hand corner of the letter. The pen is lifted back to the top left-hand corner and placed on the already black ink, which gives a good, strong junction. A quick pen lift results in a small point at the top right-hand corner. This is a focus for the eye to be led on to the next letter. The right-hand stroke of a is made in a swift movement, which again bounces off the bottom line.

Family groups

Pointed base: a, d, g, q, u, y
The curve at the bottom of the left-hand downwards stroke of a, d, g and q is sharp, so that most of it appears parallel to the second downwards stroke. The sharp bottom of u and y gives a good family likeness. The serifs of descenders go forwards and up, to carry the eye back to the reading line.

Rounded base: o, s, c, e, t, l
The bottom curve is rounded and the letterforms look like narrowed Foundational hand.

Crossbars: t, f
f can stop at the line or extend below it, depending on what you think best. The crossbar is at the same level as t.

Arched letters: n, m, h, k, b, p, r
In theory, the n is an upside-down u – but the arch is curved to increase the weight at the top third of the letter. b and p must be the same width as n. The k looks like an h with a karate-chop in the belly, and is a little wider than the h to balance the white space.

Diamond strokes: i, j
A short diamond stroke above the x-height forms the dot of i and j.

Diagonal strokes: x, v, w, y, z
The slope of awkward letters like v is created by an imaginary line which bisects the counter-space from the bottom of the letter to the top. A flatter pen angle may be needed to keep the narrow strokes distinct.

adgquy

os ocetl tf f

nmhk bpr

i j

x vwyz v

Capitals

Pen angle and weight

Use a 30 degree pen angle, rising to 40–50 degrees for diagonal strokes. Letters can sit upright or lean forwards from the vertical by approximately 5 degrees. If they lean much more than that, the letters will appear to be falling over. For minuscules written at 5 nib widths, write capitals at 7 nib widths.

Italic capitals are made in a similar way to Roman capitals, except that the forms are based on an O that is narrower than a circle – here, it is narrowed to ⅔ of its height. The H and the other letters are narrowed correspondingly. Care must still be taken to think about the width of the letters in relation to each other, so it is important to look at the internal shapes of the letters as well as the overall width of the finished letters. Spacing Italic capitals is similar to spacing Roman ones, but as the space inside the Italic O is narrower, the space between Italic capitals should be correspondingly narrower.

Family groups

Oval letters: O, Q C, G, D
The bowl of D echoes the right-hand curves of O and Q. The tops of C and G are flattened.

Rectangular letters: H, T, U, Z
The crossbar of T is exactly the same width as the crossbar of H. Completely flatten the pen angle to make the centre stroke of Z. H and U should be ¾ the width of O. If this makes them look too narrow, they can be made a fraction wider.

Small bowl letters: B, P, R, S
The bowls of B, P and R should relate to the oval O, but unlike the Roman letters, they need not be as narrow as half the O shape.

Diagonal letters: A, V, W, X, Y, N, M
These are narrowed Roman letters. Their widths relate to that of the italic capital H.

Straight letters: I, L, J, E, F, K
These are also narrowed Roman forms. The second stroke of K only just touches the first stroke of the letter.

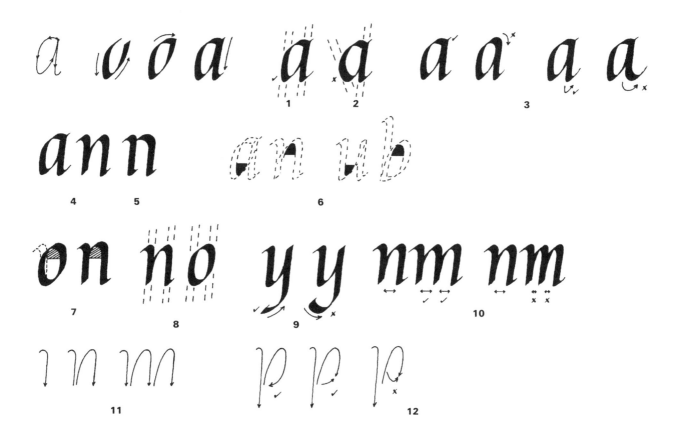

Learning to write Italic

Start with minuscules. Mark out your nib widths and rule up the page. Look at the family groups on p. 73 and Bembo's Sonnets on p. 71. Use these and the practice alphabet on p. 77 as a guide for writing the letters of the alphabet between the lines you have ruled. Check that your letter strokes look parallel and evenly spaced.

1. The first (left-hand) stroke of a must be parallel to the third.

2. The curve should be barely perceptible – this letterform is incorrect.

3. Make sure there is a focus point at the top right-hand corner and that the bottom serif is sharp, not curvy.

4. Since a is the key letter, the n has the same thin skating diagonal going into the arch.

5. If the alphabet was based on an oval o, the arch of n would be a narrowed Foundational letter without the thin diagonal. The letter shown is incorrect.

6. The white shapes inside a and u should be similar, and very slightly rounder in n and b.

7. The inside of the n should differ from the inside of the o; here are two examples of where they have been written incorrectly.

8. The curves of o only happen at the top and bottom of the letter; the uprights should appear parallel to the uprights of the n, as here.

9. The tail of y goes forwards and up (left), rather than casting the eye downwards (right).

10. Each part of m is the same width as n, to give a regular distance between upright letter strokes (left correct, right incorrect).

11. More control may be possible by lifting the pen off the page at the end of each stroke and re-placing it exactly where it was before the next stroke.

12. The bowl of p may be made in one movement, even though this involves a 'push stroke'; a broken line at the bottom is better than a triangle (right).

Weight and form

Choice of weight and form depends largely upon the content and size of the piece of work you are creating. The examples below show how varying weight and form can create differing impressions. A quotation in lightweight letters has a very different look to the same quotation written in heavyweight letters. Always give careful thought to the meaning and mood of a piece before choosing the letters that best convey the message.

1. The letters are written at 7 nib widths, as in the family groups, but have been narrowed and are therefore placed closer together.

2. The letters are written with the same nib but at 10 nib widths. The increased white space makes them appear lighter in weight than the letters above. Their serifs have been varied to give them a different appearance.

3. The letters are written with a narrow nib, using the same proportions as in the family groups but at a very light weight.

4. The same narrow nib is used here, but the O shape has been narrowed and the letters are placed closer together, to give a denser feel.

5. These heavyweight letters have been written at 5 nib widths.

6. These letters were written with a centre guideline, and have been allowed to move up and down.

Numerals and punctuation

Italic has tall letterforms, so it is less necessary to vary the height of numerals to ensure they contain enough white space. They are generally written at the height of the capitals. Keep the curves in long verticals such as 9 to a minimum, so that, as with the letters, the stress is in the uprights. The overall width of each number (except 1) should be the same.

Punctuation marks carry the same forward slope as the letters, and the question mark is narrowed – otherwise, they are the same as Foundational.

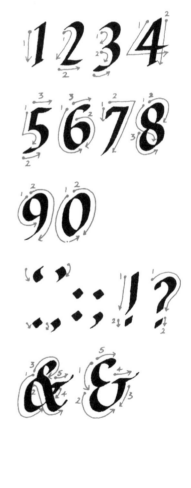

DENSER, DARKER
1
TALL NARROW
2
LIGHTWEIGHT LETTERS
3
NARROWED AND CLOSELY PACKED
4
HEAVYWEIGHT
5
FREELY WRITTEN CAPITALS
6

Practice alphabet

Practise your writing using a wide nib. Start by copying the letters in their family groups (p. 74), to feel how their shapes relate to each other, then use the letters to write single words or a quotation – in minuscule, in capitals and eventually a mix of the two. This will help you to practise letters and spacing at the same time.

When you are more confident, begin to write letters at different weights and sizes, as in the examples shown opposite. You can do this by altering the number of nib widths in the height of the letters, or by changing the size of your nib.

abcdefghijklmn
opqrstuvwxyz
ABCDEFGHIJK
LMN OPQRST
UVWXYZ

MENU CARD

Handwritten cards and stationery are always appreciated for a special occasion. Italic hand is one of the most popular scripts today: it is very legible and works beautifully in different sizes. This Italian menu card uses a simple, centred layout and various sizes of text. Adding small decorations or border lines will make the stationery feel even more special and personal.

Project by Emiko Hashiguchi

You will need

2 or more sheets A3 layout paper, min. 45 gsm/31 lbs

1 sheet A3 hot-pressed paper, c. 300 gsm/ 140 lbs

HB pencil

30 cm (12 in.) ruler with metal edge

2 pen holders

Square-edged nibs in at least 3 sizes (here, Mitchell nibs in sizes 2, 3½, 4, 5 and 6 are used)

Black ink (stick ink or gouache)

Watercolour paints or gouache in colours of your choice

Fine pointed nib or small pointed brush

Ruling pen

Bone folder

Craft knife (optional)

Cutting mat (optional)

Simona e Piero
50° Anniversario

Spritz al fragole, limone e prosecco
Tagliere di salumi e formaggi

Bruschetta bianca (con aglio e olio)

Risotto zucchine e gamberetti

Spigola con olive e pomodori
Insalata verde

Sorbetto al limone

Caffè

Prosecco Doc di Treviso
Bianco conti di Maestranza
Tavernello rosata

How to make

1 Decide on a menu. Think about how many items you have to write out, and sketch a few layout ideas based on this - think about spacing and legibility. Make a range of pencil sketches in various sizes, shapes and layouts to work out what will best suit your text.

2 Mark out an area on your layout paper the same size as the available writing area on your hot-pressed paper. Remember that the menu will be folded, so you are working with half of its total area (for more on layouts, see pp. 24-6). Work within this area when you practise your lettering.

3 Begin to write out the whole text in pen on the layout paper, trying various different sizes and weights. Think about which words you would like to emphasize and how they should fit together, and decide on the size and spacing of the text. Follow the guidance on pp. 72-7 if you want to use italic text; you could also choose a different lettering style.

4 Think about how you would like to decorate the text - here, leaves have been used to divide the text into sections. Experiment with different decoration styles on the layout paper.

5 Make a paste-up. Scan some of your preferred pieces and move the words around on the computer; or take a photocopy and cut and paste the lines of text to create different layouts based on your sketches. Remember to work out the space between lines, too. On the menu shown, the title is larger and the date is smaller than the main menu text, and all of the text is centred.

Make a paste-up based on your designs.

6 Cut the hot-pressed paper to size, if necessary. Make sure that the grain is running vertically so that the paper can be folded cleanly (see p. 27). Lightly mark where the fold should be in pencil, but do not fold it yet - the page needs to be totally flat for you to write on it.

7 Rule up the pages, following your paste-up layout. Write out all the text as planned, keeping your design close by for reference.

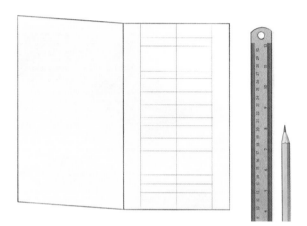

8 Add the decorations between the items using a fine-pointed brush. You could use leaves, flowers or abstract patterns - just make sure that the size and shape complements your writing rather than distracting from it.

9 Mark out the position of the border lines in pencil on the front page. Fill the ruling pen with your chosen colour using a brush, and draw the outside lines first. Clean the nib and repeat with the second line, which should be a few millimetres inside the first.

10 To finish, once all the ink is completely dry, fold your menu in half using the bone folder.

Once the ink is completely dry, fold your finished menu in half.

Now try...

Using pen flourishes (see pp. 118–23) to add an extra decorative touch. Try to strike a balance between beauty and legibility; flourishes can create particularly attractive titles and initials, but may make running text difficult to read.

CAPITALS &

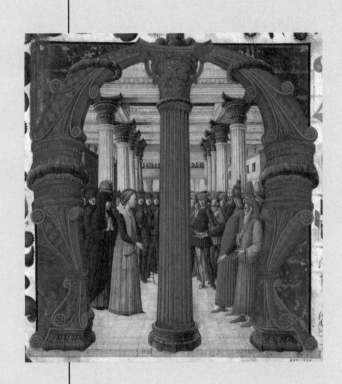

INITIALS

Capital letters were among the earliest forms of formal Latin lettering. They are often found adorned with gold leaf or elaborate illustrations – the *c.* 320 Codex Vaticanus, among the oldest surviving manuscripts of the Greek Bible, includes decorated initials. As Western book production became increasingly professionalized, moving gradually from monasteries to urban centres during the late Medieval and early Renaissance periods, so did specialist skills like illumination – the practice of decorating text or images with gold or silver.

Facing page, top: Girolamo da Cremona (illuminator), historiated 'M' cut from a choir book, c. 1462, Lombardy, 21 x 19 cm (8⅜ x 7½ in.), V&A: 817-1894

Facing page, bottom: A. W. Pugin, design for 'IHS' wallpaper (detail), 1850, Great Britain, 49.5 x 30 cm (19½ x 11⅞ in.), V&A: D.1063-1908

Top: Girolamo dai Libri, 'B' with David playing the lute, c. 1480-90, Verona, 27.5 x 27 cm (10⅞ x 10¾ in.), V&A: E.1168-1921, Bequeathed by D. M. Currie

Left: The Kinloss Psalter (detail), c. 1500-30, Scotland, 30.8 x 23.4 cm (12¼ x 9¼ in.), National Art Library, V&A: MSL/1902/1396 (Reid 52), f. 110v, Given by George Reid

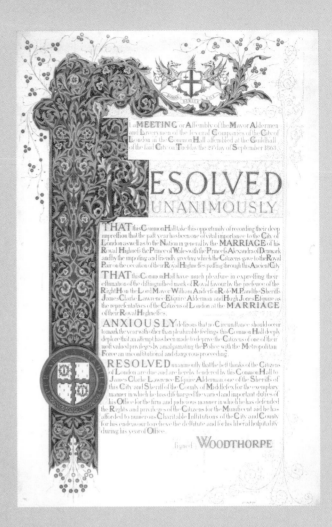

Above left: Karl Schmidt-Rotluff, woodcut monogram, c. 1929, Germany, 13 x 13 cm (5⅛ x 5⅛ in.), V&A: E.1300-1963, Bequeathed by Dr Rosa Schapire © DACS 2018

Above right: Owen Jones, Illuminated Address from the Corporation of the City of London to Alderman Lawrence, 1863, London, 46.4 x 68.6 cm (18⅜ x 27⅛ in.), V&A: D.1347-1897

Left: Initial 'S' from a choirbook, late 12th century, Netherlands, 8.3 x 8.3 cm (3⅜ x 3⅜ in.), V&A: 244:3

In Italy, a major centre of manuscript production during the Renaissance, the sophisticated styles of fresco and easel painters were reflected by skilled illuminators and miniaturists – so much so that the 16th-century illuminator Giulio Clovio was known as 'the little Michelangelo'. Some artists worked across media: the Florentine Gothic painter Lorenzo Monaco, a monk of Santa Maria degli Angeli from 1391 and the head of the *scriptoria* there, created large, panelled altarpieces, a fresco cycle and miniatures for choirbooks in his lifetime.

Manuscript illumination and decoration all but died out with the rise of printed books – though at first, room was left in the printing of more expensive books for hand-illuminated initials. Woodblocks, stamped onto the page, were used for illustrations and sometimes for decorative capitals; these blocks resemble the seal stamps, often cut with their owner's initials or emblem, also in use at the time. Rare early survivals of embossing were made using the same relief-cutting techniques used to create these seals and woodblocks, though these tend to be images rather than text. More recently, embossing techniques have been significant to the development of Braille.

Contemporary decorated capitals and initials often display a mixed-media approach: hand-lettering, printing, embossing and debossing, illuminating and painting. They are popular for special, occasional pieces such as invitations and cards, and modern-day scribes produce a mixture of classic and experimental styles – for example Timothy Noad, a calligrapher and heraldic artist who hand-letters British Royal Charters and Letters Patent, in a tradition stretching back to 1066, while also producing playful, highly original work.

Above: Initial 'R' from a choirbook, 14th century, Netherlands, (closed mount) 7.8 x 9.9 cm (3⅛ x 4 in.), V&A: 249:6

Left: Timothy Noad, *Salamander*, 2017, 12.5 x 11.5 cm (5 x 4⅝ in.)

DECORATED LETTERS

Puzzle Initial, 16th century

This type of ornate initial is commonly known as a 'puzzle initial' because of the way two colours combine to form the body of the letter. In this example, intricate red and mauve pen-flourishing surrounds the letter in a lace-like pattern. While highly decorative penwork was used throughout Europe in the Middle Ages and the Renaissance, the shapes and colours varied widely from one region to the next.

This large initial was cut out of the book it belonged to, but its appearance indicates an early 16th-century Spanish origin. Its generous dimensions further suggest that it came from a choirbook: such books needed to be particularly large, as they were used in church for the entire choir to sing from.

Ink and colours on parchment, Spain, 8.8 x 8.4 cm (3½ x 3⅜ in.), V&A: 7951

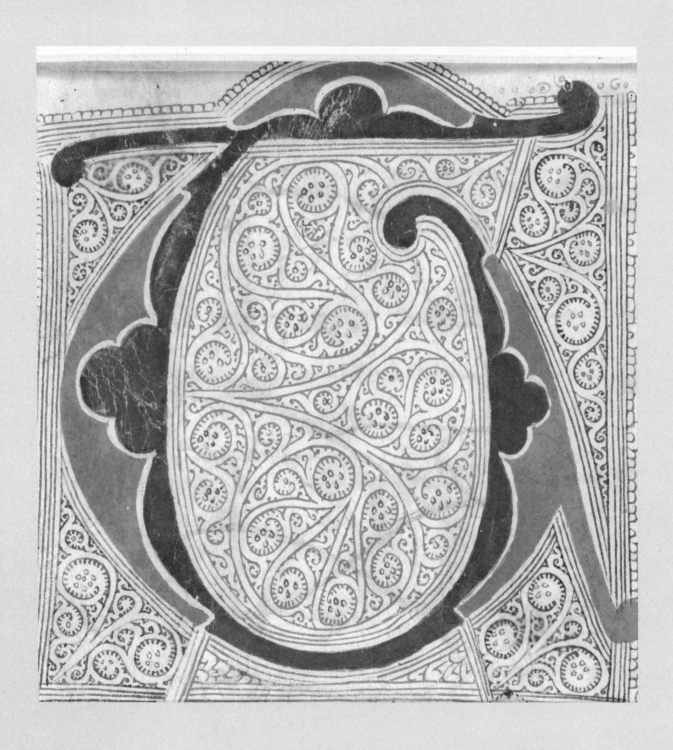

FRAMED LETTER ART

This bright, decorative piece draws inspiration from the strong colours and arabesque scrollwork found in Renaissance manuscripts like the Spanish example on p. 86. It is painted onto vellum, a writing material made from animal skins which has been used for over two millennia, often for documents of great importance – from British Acts of Parliament to Bibles.

Project by Keiko Shimoda

You will need

2 or more sheets of A4 layout paper, min. 45 gsm/31 lbs

Sheet of calfskin vellum, A6 or approx. 15.2 x 10.2 cm (6 x 4 in.)

Note: *if you prefer not to work on vellum, 'paper vellum', which has a similar texture, can be found in many craft stores. You will not need the gum sandarac, linen bag or dust mask.*

Gum sandarac

Linen or other loose-weave fabric bag

Dust mask

HB pencil

30 cm (12 in.) ruler with metal edge

Pointed brush, size 00

Pointed brush, size 2

Monoline pen

Broad-edged nib, size 2 (here, a Speedball C2 nib is used)

Pointed nib (here, a Gillot 303 nib is used)

Gouache paint in a selection of colours

Frame, A6 (c. 6 x 4 in.) or larger

Craft knife (optional)

Cutting mat (optional)

How to make

1 Decide on the size of the finished piece (the project shown is 14 x 10 cm (5⅝ x 4 in.), with some variation from the shape of the vellum). Choose your word. Here, *nitor*, meaning 'brilliance', is used - if you would like to replicate this project, use the initial template on p. 93. Think about the size of your vellum and the space available. The capital is the main feature in this piece, so think about how that will look.

2 Use the layout paper to plan your design. Remember the first letter will be much larger than the rest of the letters. Rule out a square roughly the right size for the decorative initial on the layout paper. Sketch the initial, using the square as a guide. For a style of lettering similar to the one used here, use circle shapes within the square.

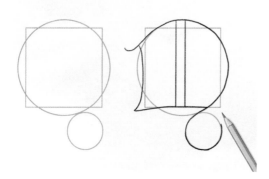

3 Make your design smoother and start adding details like flourishes, tails and curls. You may wish to experiment with several different designs until you are happy with one. Look at the images on pp. 82-5 for inspiration.

4 Still working on the sketch, decide which areas of your letter will be solid colour, and whether you will use just one colour or two, as in the project shown.

5 Sketch the detailed decorative area around the outside of the letter, too. Refer to the template on p. 93 or design your own shapes. Take your time to make sure that you are happy with the design.

6 Once you are satisfied with your design, outline the basic shapes with a monoline pen. Make sure the lines are clear and dark.

7 Cut the vellum to size if necessary, using a craft knife and cutting mat.

8 Using a pencil, trace the shape of your letter onto the writing surface - vellum is translucent, so you should be able to see the design clearly through it. Don't press too hard. Any errors can be scraped off with a scalpel or razor blade (see p. 29).

9 Paint the largest coloured area first. Dilute a small amount of gouache to make a 'wash'. The wash will make it easier to fill the surface with more concentrated colour. Outline the area using undiluted paint and a small brush, to stop the paint from spreading. Paint the areas of block colour with the wash, using the medium brush.

Develop your lettering design, making smooth
curves and adding curls and flourishes.

Vellum

Traditional vellum is made from calfskin – the
name comes from the Latin *vitulinum*, meaning
'made from calf'. The surface is smooth and
hard-wearing. Nowadays, alternatives are
available – modern 'paper vellum' is a made of
synthetic plant material.

If you are working on a piece of vellum that is
larger than around A5 size or an illumination with
large areas of paint, it is best to stretch it over a
board or frame before it is ready to be written on.
Vellum absorbs moisture and becomes wavy when
it's wet. In this project a small piece is used, so it
is not necessary to stretch it. If the surface of the
vellum is uneven after you have decorated it, you
can straighten it out by putting it under a weight
(such as a pile of books) for a few days.

10 Paint the area you have 'washed' with
the more concentrated colour, which should
be a thick liquid consistency.

12 Repeat these steps for any other block
colour(s) in your design.

13 Wearing a dust mask, treat the surface of the vellum. Add a teaspoonful of sandarac to the fabric bag and secure tightly. Gently dab the bag across the areas of the vellum where you will add writing or pen decorations - only a very little is needed. Too much will make it difficult to write. Excess can be removed with a clean, dry brush.

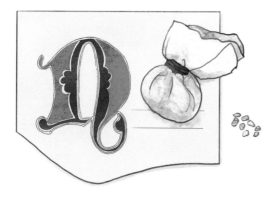

Patterns & decorations

For patterns, you could take inspiration from pieces in museums, like the arabesque work on p. 86, or from contemporary designs. Some ideas:

Inside the letter: divide the area into three. Use the small brush or pointed pen to draw delicate patterns inside each section.

Corners: use your original square guide to help shape these. Sketch out a pattern to fit – here, stylized foliage is used.

Frills and lines: use a small brush or pointed pen to draw small, light frills from a centre point outwards. Enclose the whole letter with several outlines sitting close together.

Dots: make a firm dot and pull the tail out from it, so that the shape looks like a tadpole. Create an extra outline or part-outline with these, moving the vellum around so that your hand is comfortable.

14 Begin to fill the area around your letter with patterns, using a pointed nib and the gouache. If you prefer, you can use a pencil to lightly mark out the design first, or trace it as before from your earlier drawing.

15 When you are happy with the letter and the ink is dry, very lightly rule out the area for the rest of the word in pencil. Write the rest of the word in black gouache using your broad-edged nib, referring to pp. 62-5 for the lettering style. If the ink looks a little less crisp, you may need to apply more sandarac to the surface.

16 Allow the ink to dry, then set the vellum on the backboard of your frame. If the frame is deep enough, you could use foam 'spacers' (sticky foam pads, widely available at craft shops) to 'float' the piece and emphasize the wavy, irregular form of the vellum.

Template

Now try...

Adding a 'miniature' painting. See pp. 82–3 and 84 for inspiration. You could draw anything you like in the space inside your letter – try to relate it to the word or phrase you are writing. Scenes from a narrative work particularly work well!

ILLUMINATED LETTERS

Leaf from a Gradual, 1392–9

This detached leaf was once part of a Gradual, a choirbook which contained the chants sung during the Catholic Mass. This particular choirbook was made for the monastery of San Michele a Murano in Venice in the late 14th century. The illumination is attributed to Don Silvestro dei Gherarducci, a monk of the Santa Maria degli Angeli monastery in Florence, which was renowned for its manuscript production. The lavish initial S and the ornate script below it spell out the first words of the Mass for Pentecost. The decoration shows the Holy Spirit descending on the Virgin Mary and the Apostles and, below them, more followers of Christ assembled.

The practice of cutting up manuscripts to sell pieces separately was particularly widespread in the 19th century, and the large size and rich decoration of Italian choirbooks made them prime victims. The Victoria and Albert Museum purchased such fragments as examples of calligraphy, ornamentation and painting from different periods and geographical areas.

Ink, gold and colours on parchment, Florence, 57.5 x 40 cm
(22¾ x 15¾ in.), V&A: 3045

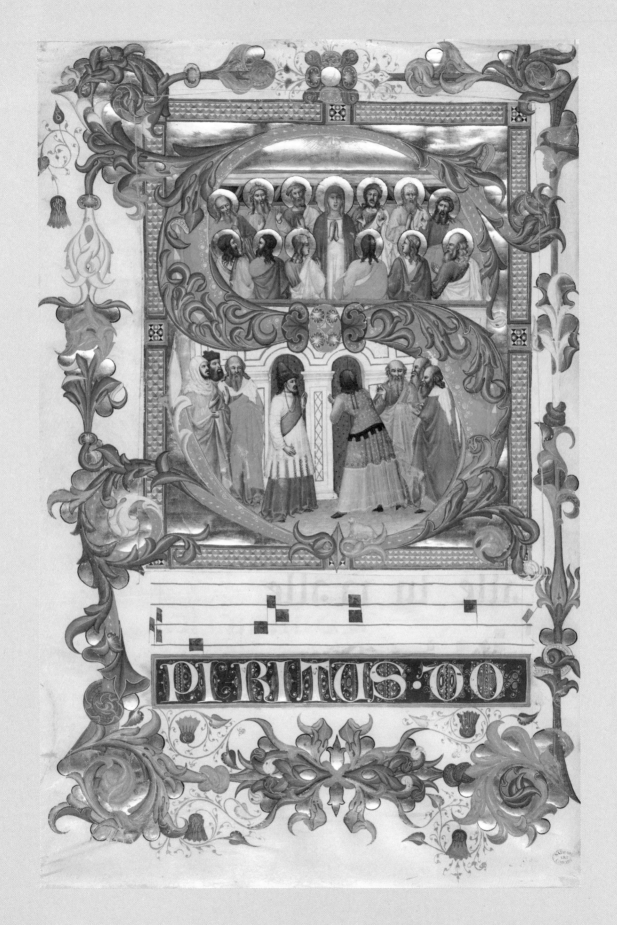

ILLUMINATED BOOKMARK

From simple tabs or found objects to elaborate markers built into a book's binding, bookmarks have been found in manuscripts from throughout the Middle Ages and Renaissance. Inspired by illuminations in the late 14th century Gradual shown on p. 95, this illuminated letter bookmark is decorated with stylized foliage and gilding in the space around the Lombardic-style capital.

Project by Emiko Hashiguchi

You will need

2 or more sheets A4 layout paper, min. 45 gsm/31 lbs
2 sheets A4 tracing paper
1 sheet A4 hot-pressed paper, 300 gsm/140 lbs
HB pencil
30 cm (12 in.) ruler with metal edge
Coloured pens or pencils
PVA glue or PVA-type base of your choice
Transfer gold leaf (this can be purchased in small 'books')
1 sheet glassine paper
Pointed burnisher
Pointed brush, size 0
Square-edged brush, size 0
Watercolours or gouache paint, in a selection of colours (here, scarlet lake, cadmium yellow, cobalt blue, ultramarine, white, vandyke brown and black were used)
Mixing brushes
Mixing palette
Water pot
Craft knife
Cutting mat
Removable tape

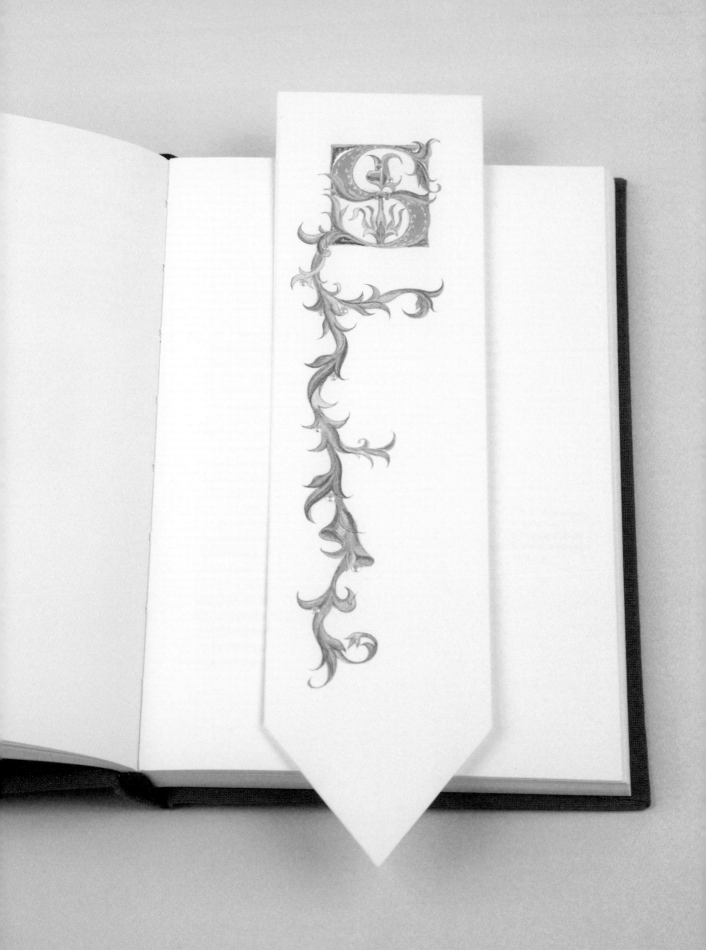

How to make

1 Decide on the size of the bookmark -
a medium-sized paperback book has a height
of 19.8 cm (7⅞ in.), and it will need to fit
comfortably. Draw out the shape on layout
paper using a ruler, or trace and transfer
the template outline on p. 101.

2 Drawing inspiration from the manuscript
page on p. 95, begin to sketch your chosen
letter and the foliage growing from it. You
could copy the inner design of the template
on p. 101, if you prefer. Make sure the
leaves look naturally curved and flowing.

3 Once you are happy with your idea,
tidy up the lines of your drawing and take
several photocopies. Colour in the design
with pens or pencils to see how different
colour combinations work. Decide which
areas of the design you will apply the
gilding to.

4 Trace your final design using tracing
paper. Then, turn the tracing paper over
and go over the lines with a sharp pencil
on the other side. Turn the tracing paper
back, place it onto the bookmark card and
tape it in position with removable tape.
Scribble over the tracing paper to transfer
the design onto the bookmark.

5 Apply the gilding before painting any
of the coloured areas. You will need to
work on a flat surface. Dilute a little PVA
glue with water until it flows easily - if
it helps to see it, you can colour it with
a pinch of red watercolour. Paint the area
to be gilded with the diluted PVA, using a
fine pointed brush. Make sure that you do
not leave brush marks, and allow the area
to dry completely. If you wish to create a
raised effect, you can add a second layer
of PVA. Wash your brush thoroughly.

Turn your tracing paper over, and go over the
traced lines with a sharp pencil.

6 Once it is dry, blow on the PVA area
a couple of times, until it becomes warm
and slightly tacky (you can also use a
hairdyer for this). Place the transfer gold
leaf quickly onto it (see opposite), and
press the gold down firmly. Gently peel off
the back. Repeat this a couple of times,
until the PVA is fully covered with gold.
You can use the pointed burnisher over the
edges to make sure that they are covered
fully. Clean the area with a small brush
and allow it to dry completely, for at least
20-30 minutes.

Test out the shades you have mixed on a scrap piece of the bookmark paper.

9 Starting with the letter, paint around the outline with a small pointed brush. Dilute a little of your chosen colour and 'wash' the area with it (see p. 91).

10 Paint over the washed area with the undiluted colour. Load the paint generously and work quickly. Paint the other colours in the same way.

11 To add some shading, paint a few more layers of the colours. For highlights, add fine lines in white or, if highlighting green, mix the white with a little yellow.

12 Draw fine, decorative patterns around the edges, and add a design or picture inside the letter with your choice of colours.

7 Lay a small square of glassine paper over the gilded area and burnish it, rubbing the burnisher all over the gilded area to smooth it. Then, remove the glassine paper and burnish the gold directly.

8 Next paint the coloured areas. Mix your colours on a palette: for orange, mix scarlet and cadmium yellow. For green, cadmium yellow and two blues. Test out the shades on a scrap piece of the bookmark paper until you are happy with the colours.

13 Mix the brown and black paints and paint around the outlines very carefully, using your smallest pointed brush.

14 Finally, once the paint is dry, cut the bookmark to size using a craft knife, metal ruler and cutting mat.

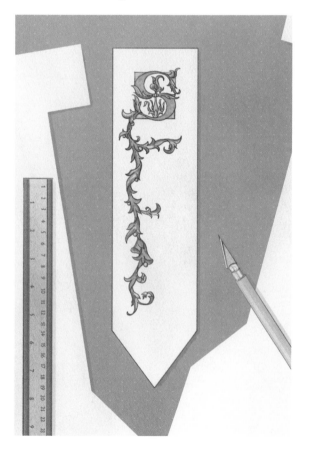

Once the ink has dried, you can cut the bookmark to size and begin using it.

Now try...

Drawing different lettering styles. Illuminated lettering can be used for cards or calligraphy artworks. Take inspiration from historical works and from lettering designs in advertising, books and magazines, and combine your illuminated letters with the calligraphic scripts you have learned.

Template

EMBOSSING & DEBOSSING

Untitled, 2007

Michael Shaw is best known as a sculptor. He often explores the character and potential of concave and convex forms and geometric shapes such as ellipses. Inverting the traditional qualities of sculpture, he creates physical objects that allude to ideas of invisibility and weightlessness. Here, an elliptical piece of stiff, handmade paper with an uneven edge has been impressed to create two smaller, letter-like ellipses, which are placed asymmetrically in relation to each other and the paper itself.

Blind debossing – the opposite of embossing – is a process of printing without ink in order to leave a lasting indentation in the paper. The indentation is made using a printing plate or a metal die. Here, it has been used to create an abstract image that plays with the viewer's perception, echoing Shaw's work in other media.

Michael Shaw (born 1973), blind debossing on handmade paper, London, Great Britain, V&A: E.664-2009, Given by the artist

EMBOSSED LETTERS

The sharp, clean contrast between the raised and flat areas of embossed letters gives depth to the lettering, and the play of light and shade can be very beautiful. The linocut method of embossing, used in this project to make an 'ABC', produces curved letters which increase in depth and create subtle shadows.

Project by Susan Hufton

You will need

2 or more sheets A4 layout paper, min. 45 gsm/31 lbs
1 sheet A4 tracing paper
2 sheets A4 soft printmaking paper, min. 300 gsm/140 lbs
HB pencil
Double pencil (see p. 36)
Medium-size brush, for soaking the paper
Lino block, approx. 23 x 10 cm (9 x 14 in.)
Lino gouges: 1 small curved and 1 small v-shaped
Craft knife
Burnisher or other embossing tool - a smooth pebble or bone-handled knife is fine
Bowl and clean towel
Toothbrush or other small brush
Cutting mat or other non-slip surface
Bench stop (optional)

How to make

1 Rule up the layout paper and begin
to draw out your chosen letters using a
double pencil. The piece shown on p. 105
is 10.5 x 22 cm (4¼ x 8¾ in.). Redraw or
trace your letters until you are satisfied
with the result. Be careful of very thin
lines, wide areas and acute corners; these
will be tricky to cut out cleanly.

2 Trace the design using your tracing
paper. Flip it and trace over the lines
with a sharp pencil.

3 Transfer the reversed drawing onto the
lino by placing the reversed tracing paper
onto the block and scribbling over the back
to transfer the pencil marks.

4 Place the lino block on a non-slip
surface such as a cutting mat. If possible,
use something to stop the lino slipping
around as you cut it - for example a bench
stop. Working slowly, begin to cut out the
shapes. First cut around the outline with
a craft knife or scalpel.

5 Next, use the v-cutter to cut a channel
down the middle of the letter strokes.

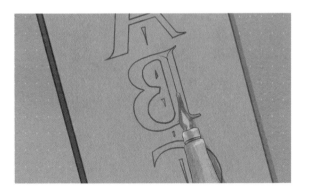

6 Use the curved cutter to scoop out the
rest of the lino. Brush out the fragments
of lino with a toothbrush as you work, to
keep the channels clear. Aim for a smooth
u-shaped channel with sharp, clearly
defined corners on the serifs and angular
parts of letters. Make sure not to undercut
the edges of the channels. Any unevenness
will show.

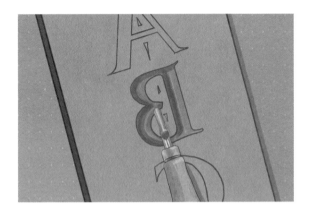

7 You can take an 'impression' at any time
to evaluate the cutting progress. You will
need to take several impressions until you
are happy with the results of first your
cutting and then the embossing itself. Take
time to practise applying the right level
of pressure.

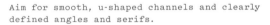
Aim for smooth, u-shaped channels and clearly
defined angles and serifs.

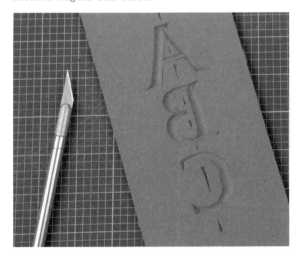

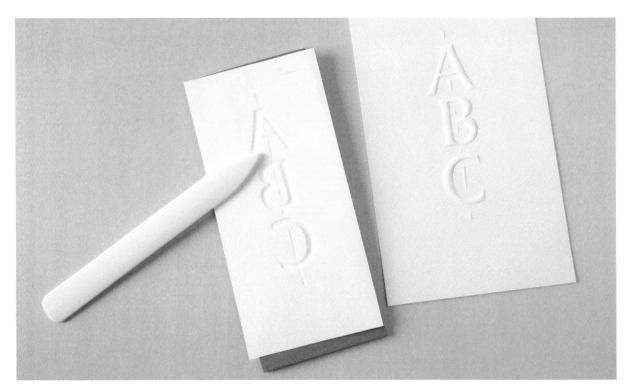

You can begin the embossing process using a bone folder around the cut edges of the letters, but take care not to poke the end through the damp paper as you work. Complete the process with a rounded tool such as a burnisher, to push the paper down into the channels.

8 To practise for your final piece, first dampen the printmaking paper using water and a brush or immerse it in water and blot with a towel. Place the damp paper over your lino block. Press through the paper with with your thumb to find where the letters are and help anchor the paper in place on the block. Using your burnisher, work the paper into the cut shapes. This first impression will tell you which areas need more work and help you to figure out how hard you need to press.

9 Keep making impressions until you achieve the result you want. Make sure that the letters are sharply defined and all areas that have been cut out on the lino are showing up as raised areas on the paper. Once you are happy with your impressions, dampen the paper for your finished piece and emboss it, working slowly and taking care to apply the correct level of pressure.

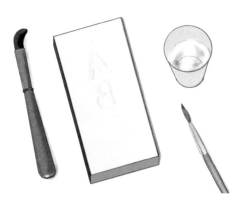

Now try...

Embossing a logo for headed notepaper: combine a symbol with lettering to create a distinctive design. You can take multiple impressions from one lino block, making it possible to create a whole batch of bespoke notepaper for yourself or as a gift.

MONOGRAMS

Bookplates, 1929

'A bookplate is to the book what a collar is to the dog,' said Edward Gordon Craig of his clean, unfussy designs. This small, understated monogram of a K superimposed on a CP typifies the 200 or so bookplates he produced. Below is the first printing, made before the background was cut out completely to create the version shown opposite.

These modest pieces belie their revolutionary maker. Craig was the son of acclaimed Shakespearean actress Ellen Terry and architect Edward William Godwin. He became a revolutionary stage designer, using wood engravings to express his minimalist ideas. Upon seeing Craig's engravings for a 1912 production of *Hamlet*, his friend and mentor Count Harry Kessler commissioned him to develop them into illustrations for an edition by Cranach Press. The volume is now considered to be among the finest examples of 20th century book art.

Made by Edward Gordon Craig (1872–1966) for Count Harry Kessler (1868–1937). Wood engraving on paper, London, 2.2 x 3.5 cm (⅞ x 1½ in.), V&A: E.964-1959, Given by Mr James Laver CBE

MONOGRAM STAMP

This small, hand-carved stamp, made from an eraser, is inspired by the woodcut prints shown on pp. 108–9, which were used as bookplates. The stamp can be re-used, so you can experiment with colours and layout as much as you like. It makes a great personalized card, and could also be used as part of a label or notepaper.

Project by Keiko Shimoda

You will need

2 sheets of A4 layout paper, min. 45 gsm/31 lbs
1 sheet A4 tracing paper
2 sheets A4 good-quality printing or watercolour paper, min. 200 gsm/120 lbs (try coloured or handmade papers)
Rubber eraser, 5 x 5 cm (2 x 2 in.) or larger
HB pencil
30 cm (12 in.) ruler
Monoline pen
Scalpel
Cutting mat
Ink pad
Toothbrush or other small brush

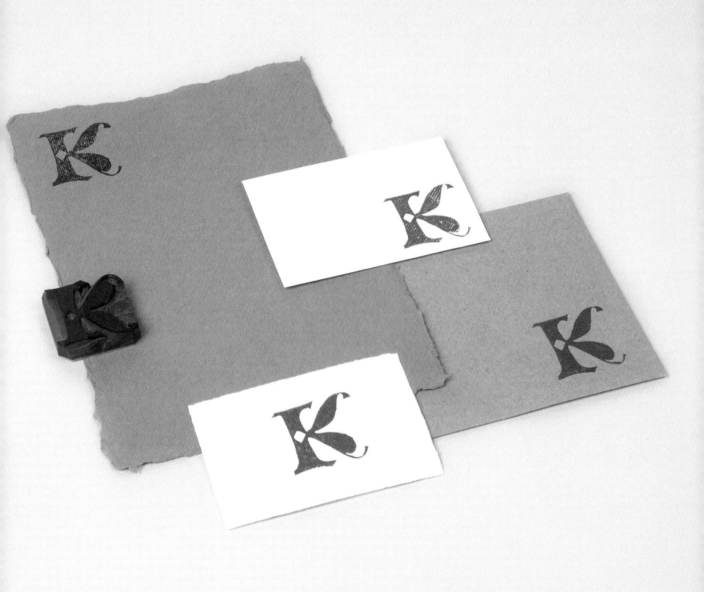

How to make

1 Using your pencil and ruler, draw a square on your layout paper, making sure that this is slightly smaller than your eraser. This will be the area of your stamp.

2 Begin to sketch out your chosen letter/s in the space. Try different layouts and lettering styles until you are happy with your chosen design - practise and refine it. It works well to fit the edges of the letters to the edge of the square.

3 Go over the outline of your chosen design with the monoline pen. Mark the corners of your square too.

4 Using the tracing paper, trace the outline in pencil.

5 Flip the tracing paper over and place it on the eraser, using the edge-marks to make sure it is lined up correctly. Scribble over the back of the paper with a pencil, pressing firmly, to transfer the pencil marks to the eraser.

6 Cut the eraser to the size of your square using a scalpel and cutting mat, if necessary. It doesn't need to be especially neat, since you will be cutting the edges away to make the letter stamp.

If necessary, you can cut the eraser to size once you have reversed your design onto it.

7 Using a scalpel, carefully start to carve out the space around your letter. When you carve, dig the knife in at an angle, pointing away from the letter as shown. You can also use a lino-cutter for this. The result will be smoother if you make long strokes rather than short, choppy cuts. This takes a bit of practice, so you may want to try it a few times on a spare eraser. The flat letter shape left behind should be at least 3 mm (⅛ in.) above the background.

8 Using the ink pad, do some test stamps on the layout paper to check the details of your letter and make sure that the edges are smooth. Clean the stamp using a damp cloth, and make any further adjustments needed by trimming away rough areas with your knife. Repeat until you are happy with the result.

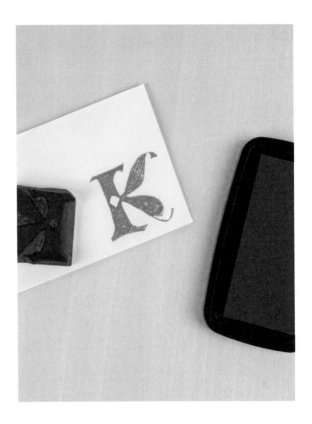

Do some test stamps using the ink pad and leftover layout paper.

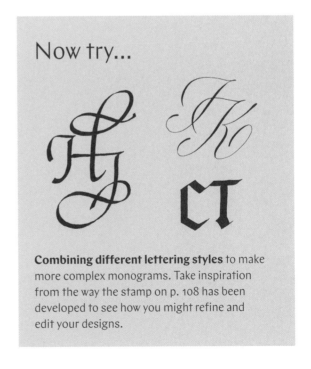

Now try...

Combining different lettering styles to make more complex monograms. Take inspiration from the way the stamp on p. 108 has been developed to see how you might refine and edit your designs.

DECORATION &

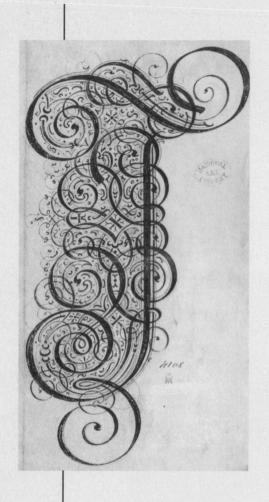

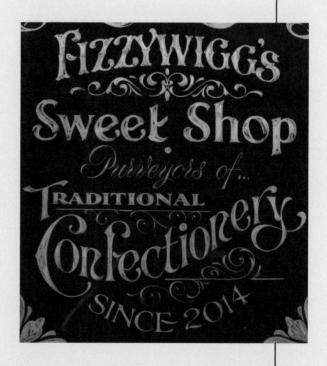

DISPLAY

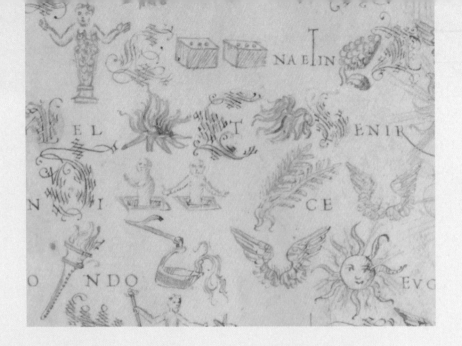

Lettering has long offered opportunities for decoration and display, whether through eye-catching flourishes, gilding, illustrations or bright paint. The survival of early scribal pattern books reveals that the extraordinary decorative lettering of the humanist scribes was learned and practised, and beauty and readability carefully balanced. Pattern books – and the rote learning with which they were associated – continued into the 18th and 19th centuries, when literacy levels began to rise in the West and having beautiful handwriting was considered of great importance.

Facing page, left: Initial 'I' in ornamental script, 17th century, Germany, (closed mount) 11.3 x 19.5 cm (4½ x 7¾ in.), V&A: 4108

Facing page, right: David Kynaston, Fizzywigg's sign, 2014, 101.6 x 76.2 cm (40 x 30 in.)

Above: Francesco Moro of Pozzoveggiano, *Arte della strozaria e farsi perfetto stroziero* (detail), 1560, Italy, 23 x 16 cm (9⅛ x 6¼ in.), National Art Library, V&A: MSL/1946/1485, f. 21r

Left: Bravo Boards, bespoke wooden house sign, 2015, Nottingham, 18 x 21 cm (7⅛ x 8¼ in.)

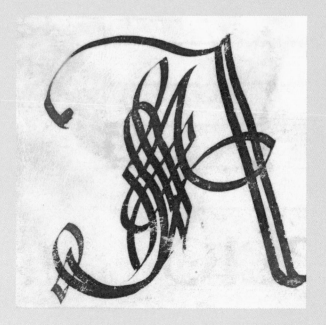

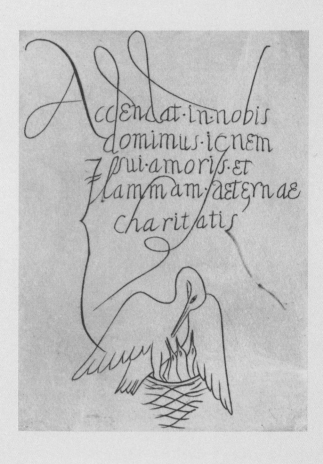

Alice Delysia,

A SUIVI LES TROUPES ALLIÉES
AVEC LE THÉÂTRE DU FRONT
DÈS LE 19 MAI 1941 EN ÉGYPTE,
PALESTINE, SYRIE, IRAK, PERSE,
TRANSJORDANIE ET LE DÉSERT
DE L'OUEST JUSQU'À EL ALAMEIN
LE 23 DÉCEMBRE 1943
Enfin LE 5 AOUT 1944
LA FRANCE, LA NORMANDIE, LA BELGIQUE

ALICE DELYSIA
est la première femme qui, avec les troupes Alliées,
a foulé le sol allemand. Cette artiste incompara-
ble, tant aimée de tous les vaillants soldats, leur
apporte inlassablement le réconfort de son souri-
re et de ses chansons.

Vive la France
Vive l'Angleterre
Vive la Belgique !

Above left: Initial 'A' cut from
choirbook, 16th century, Italy,
10.1 x 9.4 cm (4 x 3¾ in.), V&A: 7949

Above: Testimonial celebrating
the actress Alice Delysia and her
performances to French troops during
the Second World War, c. 1944, France,
59.8 x 35.5 cm (23⅝ x 14 in.), V&A:
S.599-1985, Given by John Devaut

Left: 'May the Lord light in us the
fire of his love and the flame of
eternal charity', David Jones, *The
Rime of the Ancient Mariner* copper
engraving, 1964, Great Britain,
31 x 24.5 cm (12¼ x 9¾ in.) V&A:
CIRC.423-1965

In America, John Jenkins' *The Art of Writing* (1791) called for 'a proper standard to convey our ideas by writing', and schools nationwide used writing manuals and copybooks to teach handwriting well into the 20th century.

Pattern books of a similar kind to those used by medieval scribes were also created for the signwriting trade, which began to thrive with the growth in literacy – and, therefore, in text-based advertising – from the 18th century onwards. In the UK, the popularity of titles such as *Bowles's Roman and Print Alphabets on a Large Size Complete* (1775) and the later *Alphabets for Sign Writers* suggests that styles were copied and perfected by apprentices to the trade in a manner not dissimilar to the decorative lettering of earlier centuries.

In the early 20th century, the advertising industry was influenced by a resurgence of interest in calligraphy and lettering. Edward Johnston, the 'father of modern calligraphy', was also a typographer. He created a radical new sans-serif font for the London Underground that is still used today, despite dividing opinions at the time – his pupil, the calligrapher Graily Hewitt, described it as 'his [Johnston's] block letters which disfigure our modern life'. Graphic and type designers showed a renewed interest in hand-lettering; Hermann Zapf, creator of the typefaces Palatino and Dingbats, the precursor to the modern emoji, was an especially skilled calligrapher. His fonts appear in such spots as the Taipei Metro and the Vietnam Veterans Memorial, Washington DC, and in 1960 he was commissioned to hand-write a copy of the Preamble to the United Nations Charter for the Morgan Library, New York.

Hand-lettering on signs and advertisements has an enduring appeal. Modern-day copybooks with advice on developing handwriting for signs, posters, chalkboards or even as the basis for fonts are on the rise, while artists such as Nick Garrett, a London signwriter, offer courses to an interested public as well as working on projects including house numbers and shop fronts.

Above: William Sanders for Mortlake pottery, hand-painted ceramic wine-bin label, c. 1760-70, Mortlake, 13.3 x 7.7 cm (5¼ x 3⅛ in.), V&A: C.232-1926, Given by Mr A. Myers Smith

Left: Ben Eine, *Vandals*, 2007, graffiti-inspired screenprint, Great Britain, 70 x 70 cm (27⅝ x 27⅝ in.), V&A: E.269-2013

PEN FLOURISHES

Moro's Writing Manual, 1560 ———

The first printed writing manuals in Italian were published in the early 16th century, the work of several scribes related to the papal chancery in Rome. But this particular manual, known as the *Arte della strozaria e farsi perfetto stroziero* and written by Francesco Moro of Pozzoveggiano in 1560, is in truth a sampler showcasing Moro's virtuosic skill. Little is known about Francesco Moro, apart from the fact that he was a priest who worked for several prominent members of the clergy who are named in his manuscript. The text, a miscellany of passages from a hunting treatise, famous works and legal phrasings, is a pretext to demonstrate a variety of scripts known in Italy at the time, including some of German origin as well as some Hebrew and Greek text. The extraordinary quality of this illuminated manuscript aims to emphasize the superiority of the pen over print.

Ink and gold on parchment, Italy, 23 x 16 cm (9 ⅛ x 6 ⅜ in.),
National Art Library, V&A: MSL/1946/1485, f. 14v (detail below)

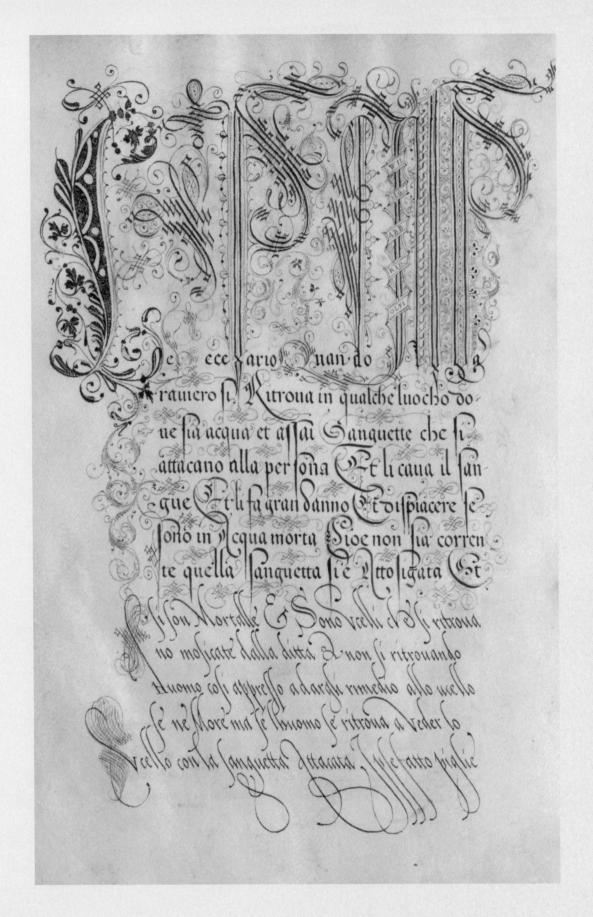

NAME TAGS

Italic is one of the most popular calligraphic scripts today, and flourishes lend an extra flamboyant aspect to the writing. Inspired by Francesco Moro's elaborate 16th-century penwork, this project uses classic flourishes to create beautiful, bespoke name tags for gifts or place settings.

Project by Emiko Hashiguchi

You will need

2 or more sheets A4 layout paper, min. 45 gsm/31 lbs

Ready-made tags or your choice of paper in a selection of colours, 250-300 gsm/ c. 140 lbs

30 cm (12 in.) ruler with metal edge

Black ink (stick ink or gouache)

Watercolour paints or gouache in a selection of colours

Square-edged nibs, size 4 and 5

Your choice of ribbons

If making your own tags, you will also need:

Craft knife

Cutting mat

Hole punch

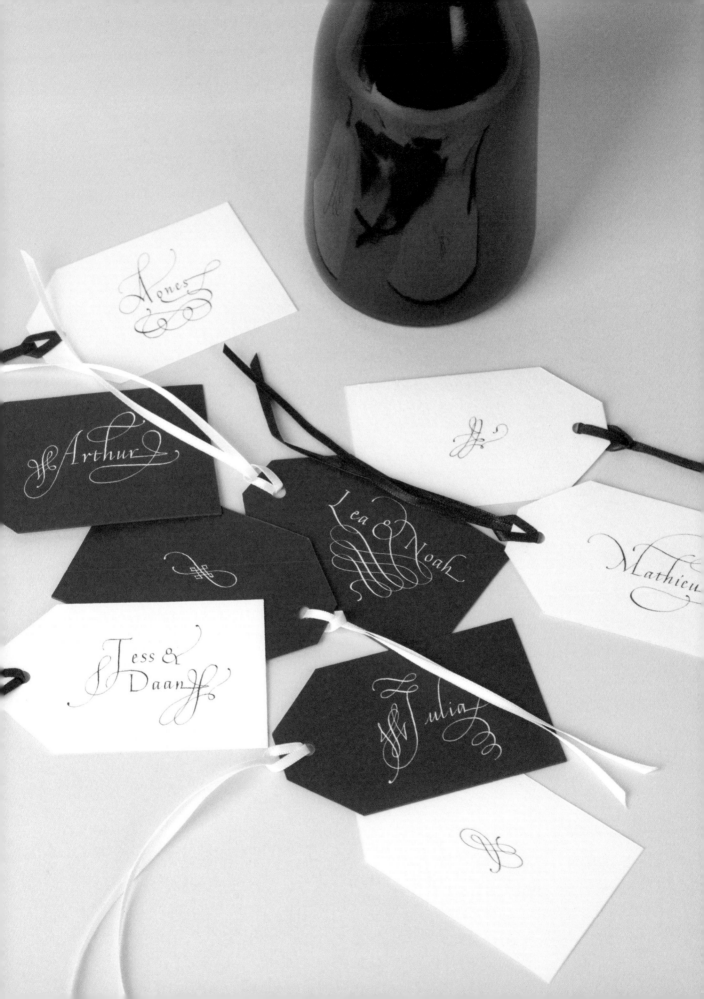

How to make

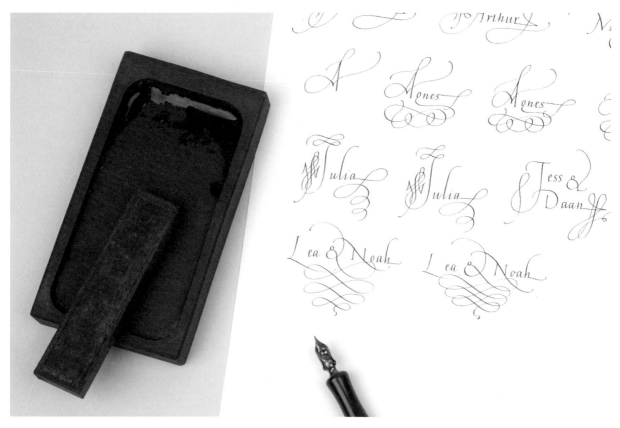

Practice writing out your chosen words in pen, using different styles of flourish.

1 On your layout paper, experiment with some variations on Italic capitals (see pp. 72-7). Make your flourishes increasingly elaborate as you get used to this way of writing. If you find the flourishes difficult to write, go over the lines several times until your hand is familiar with the movements. Start to try different styles of flourish based on those shown above and in Moro's manuscript (pp. 118-9), testing styles from simple curls to more complex patterns to see what you like best (see opposite page for some tips to get you started.)

2 Using a pencil and ruler or tracing around the edges of your ready-made tags, mark out the shape of your tags on the layout paper, so that you can begin to see how your lettering might fit in the available space.

3 Prepare the names or words you will be writing out. Sketch several different designs, using the flourish lines you have been practising. Try and strike a balance between the flourishes' beauty and their legibility!

4 When you are happy with your sketches, begin to practise writing your chosen words with a pen on the layout paper. You can break the stroke if you find it difficult to execute in one movement, but try not to show the joins - the lines should look fluid and delicate. Experiment with adding flourishes in several different colours, to add depth to your work.

5 **Optional:** *make your tags. Mark out the size and shape on your chosen paper using a ruler, cut the tags out and punch a hole for the ribbon. Do not attach the ribbon yet, though - the surface needs to be completely flat for you to write on it.*

Flourishes

This style is all about experimentation, so play around and see what works. Here are a few tips:

The original shape of the letterform shouldn't be changed by the flourishes.

Try not to cross a thick line with another thick line.

Try not to cross more than two lines at one point.

Check the space between the flourish and the letter. They shouldn't be too far away or too close.

If the flourish line contains several spaces between the lines, check each space – they should be balanced.

Pause if necessary at the thin parts (lift and replace the pen), but do not allow the joins to show.

Turn the paper and try flourishes from different directions. This can create surprising results.

6 Once you are comfortable writing the words, begin to work on the tags. Keep your final designs beside you for reference. Write slowly, trying to keep your pen-strokes unbroken so that the letters and flourishes are smooth and consistent.

7 Let the ink dry and finally, attach the ribbons to your tags.

Now try...

Making larger cards, greetings card, personalized stationery or even posters. Vary the nib sizes according to the size of the piece, and don't be afraid to experiment with more elaborate flourishes for larger spaces – look at the initials on p. 114 and p. 119 for inspiration.

CHALKBOARD LETTERING

Chalkboard, c. 1900–44

Influential British designer and calligrapher Edward Johnston (1872–1944) used a blackboard to demonstrate lettering styles when teaching at the Royal College of Art and the Central School of Arts and Crafts. Towards the top here is a lower-case or minuscule alphabet in the Foundational hand, and below it, several samples of the script fitted into ruled-up pages. At the bottom right of the board are some particularly attractive decorative designs – perhaps for a border or frontispiece. The scrolling, naturalistic forms are typical of the early 20th century Arts and Crafts aesthetic. Though this chalkboard was intended for teaching, it also displays the potential of chalk as a writing material: clear, graphic and easily erased, it is extremely useful for temporary lettering of all kinds.

Edward Johnston (lettering), Violet Hawkes (photograph), blackboard demonstration photograph, 1926, London, 12.5 x 10.3 cm (5 x 4⅜ in.)

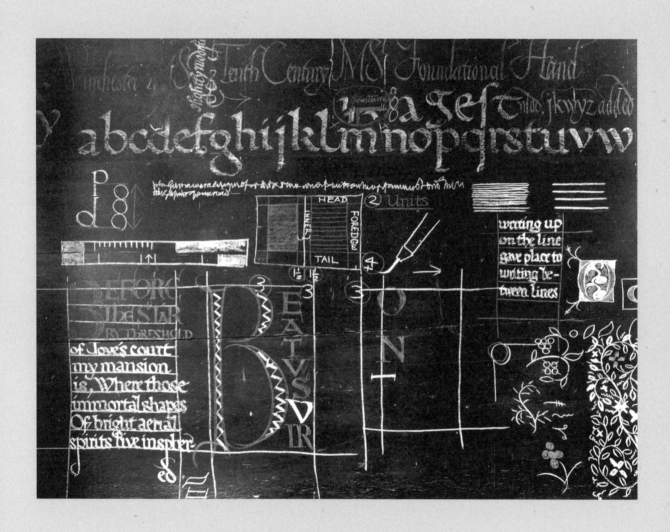

CAPITAL CITIES CHALKBOARD

This bespoke blackboard featuring the names of different cities of the world uses hand-lettering styles inspired by the iconic features of those cities and the typography that might be found on their posters and maps. You can use the technique set out here for any wording of your choice – try to relate your lettering style and any illustrative elements to the text.

Project by Michael Tilley

You will need

2 or more sheets A3 layout paper, min. 45 gsm/31 lbs

1 sheet black paper (optional, for pen trials)

Plywood or MDF board, cut to size (the board shown is A3, or 29.7 x 42 cm/ 11¾ x 16½ in.)

Chalkboard paint

Hairdryer (optional)

HB pencil

White pencil (for example, a Stabilo all-surface chinagraph pencil)

30 cm (12 in.) ruler

Selection of white chalk pens or acrylic paint pens (here, 127HS Molotow 2mm tip, 227HS Molotow 4mm tip, 427HS Molotow 4-8mm chisel tip and 627HS Molotow 15mm broad tip are used)

Black marker pen

Medium decorator's paintbrush

Pencil sharpener

Small spirit level ruler (optional)

Cleaning cloth

How to make

1 Paint one side of your board with the chalkboard paint. Let the first coat dry - you can use a hairdryer to speed this up if you like - before adding a second coat. Make sure you have good, even coverage.

2 Begin to plan your artwork on the layout paper. First, using the pencil and ruler, draw a rectangle the same size as your board and add margins. Think about how many words you plan to write and decide which words you want to dedicate one or more sections to and which could be written smaller. Once you have an idea of the number of sections you will need, measure the distance inside the border from top to bottom and divide it into the right number of equal-sized sections. There will be some trial and error involved in this - you are aiming for a loose, freehand style.

3 Practice writing the words out in different styles, and think about how they will contrast and work together in the finished piece. If you want to make one of the words more prominent, position it at the mid-point of the design and make it a little larger. You could also place it on a diagonal. Adding a vertical central line will help you to keep your design balanced - write some words left-aligned and others right-aligned. **Note:** *The board shown here has seven lines of text. It was divided into thirteen equal sections plus a diagonal banner space for 'London'. Creating these different sections will help you to fit in different-sized lettering and give you space to include illustrations where necessary.*

4 Once you are happy with your design on paper, and the board is completely dry, measure and carefully transfer the same grid lines to the board using the metal ruler and white pencil. **Tip:** *You could try out your designs on a piece of black paper, using the chalk pens, to get a feel for which ones look best.*

5 Mark out the letters roughly with the white pencil. If you change your mind, use a damp flannel to erase the pencil marks and re-draw them. Add simple illustrations in the background and any gaps.

6 Use the chalk pens to draw over your design carefully - take your time. First use a 2 mm (⅛ in.) tip chalk pen to outline all the letters and illustrations, then fill in the letters with the other chalk pens.

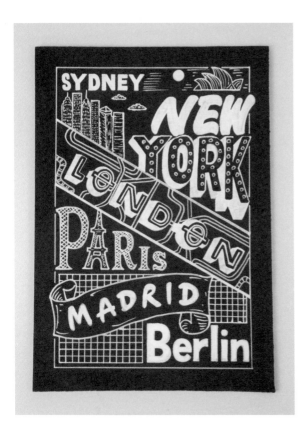

Working in a mix of chalk pen and traditional chalk, to create a board with a mixture of permanent and temporary elements. To make a weekly calendar, for example, mark a grid and the days of the week in chalk pen, and add events in wipeable chalk.

7 Wait for the chalk pen to dry, then give all the letters a second coat. Make sure that the white is bold and strong against the black background. Use a black marker to neaten any edges or erase any mistakes or extra pen marks. Leave the pen to dry fully, then wipe off the pencil marks with a wet cloth.

Practise using the chalk pens on black paper

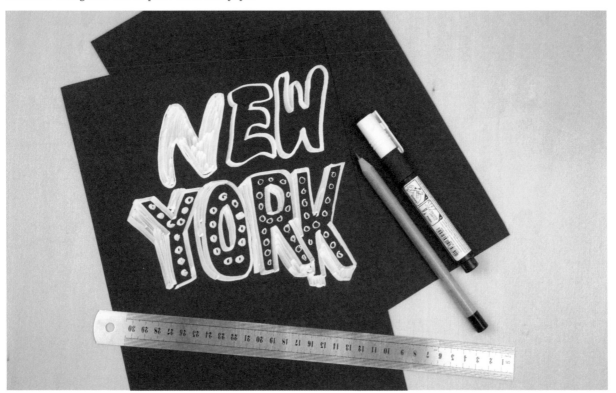

VINTAGE SIGN WRITING

Letter sample, c. 1900

Advertising was a flourishing industry by the late 19th century, and signwriters responded to a demand for bold typography to grab the public's attention from a distance. Painted on the reverse of a sheet of glass to make it durable and washable, this letter H shows how an impressive effect could be created for shops, cafés, bars or public houses. The design echoes medieval illuminated initials, while the shadowing creates the appearance of a three-dimensional form. The pink and green shades provide an eye-catching contrast and the gold has two textures, rough and smooth, to catch the light – a particularly attractive feature following the introduction of electric streetlamps in the 1880s.

Oil and gold leaf on glass, Great Britain, 30.5 x 30.5 cm (12⅛ x 12⅛ in.), V&A: 107-1955, Given by Mr H. F. Brock

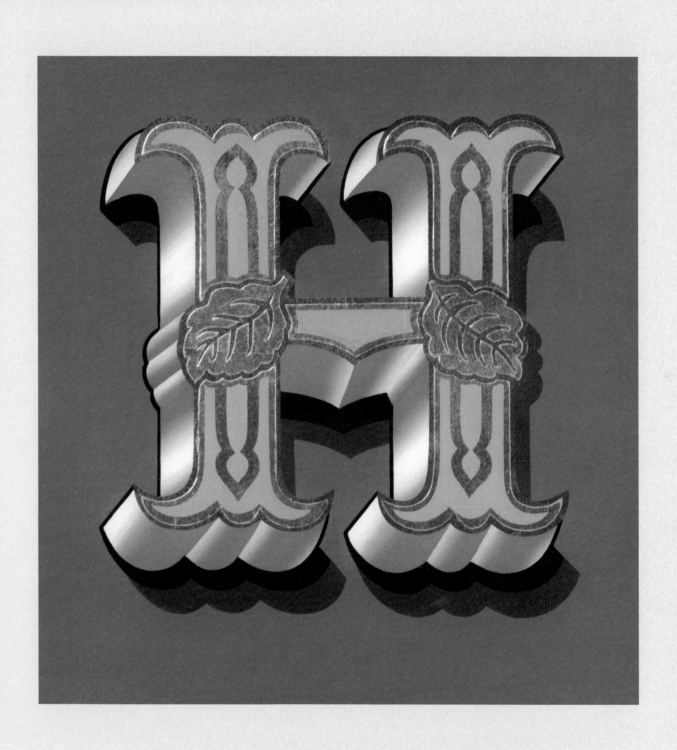

DOOR NUMBER

This number 5 is hand-painted onto the reverse of a framed piece of glass. The same technique could easily be used to paint directly onto the glass above a door or in an entrance hall. The lettering used here is an ornate style called Tuscan, which is characterized by its split serifs or 'fishtails', and was very popular in the 19th century. Simple cross-hatching lends the piece an effective 3D element.

Project by Jack Hollands

You will need

5 or more sheets A4 layout paper, min. 45 gsm/31 lbs

Glass picture frame, approx. 30 x 21 cm (8 x 12 in.), or other piece of glass for painting on

HB pencil

Grease or wax pencil

Lettering brushes in various sizes (here, Handover Chisel Writer Brushes in size 4 and 8 are used)

Signwriting enamel gloss paints in a selection of colours

Paint palette with wells

Stain remover or multi-surface cleaner that is suitable for use on glass (e.g. Bar Keepers Friend)

Cotton pads

Paper towels

White spirit

Masking tape

Straight-edge razor blade (optional)

Soft cloth, foam block or wadding

How to make

1 Draw your number or letter to scale on a piece of paper, or use the templates on p. 137, enlarging them with a photocopier or scanner and printer as required. Think about the colours you would like to use for the different elements of your design.

2 With a little masking tape, fix your drawing or photocopy right side down to the reverse side of the piece of glass you are using (e.g. the inside of the window). This is called the 'second surface'. When you look through the right side of the glass, your number should show through it the right way round.

3 Trace around the outline of the number on the right side of the glass (the outside of the window, or the 'first surface') with the grease or wax pencil.

4 Remove the paper and clean the second surface thoroughly, using a small amount of stain remover on a piece of damp cotton wool. Rub the cleaner onto the glass, allow it to dry then wipe it off. Repeat this three times to ensure the glass is thoroughly cleaned. Ensure that no soapy residue is left on the glass by wiping it with a damp piece of kitchen paper, then drying it with a second piece of dry kitchen paper.

5 Once the reverse of the glass is clean, you can paint the different areas of your design. Rest the glass on a soft cloth or some wadding to keep it tilted it towards you and prevent it from slipping. You will need to work methodically backwards through the layers of colour (see opposite).

6 Add a small amount of your outline colour to one of the wells in the paint palette (in the project shown, the outline is red). In another well, add a small amount of white spirit. Use the white spirit to thin the paint a little as you go, by mixing it with the paint on the flat area of the palette. **Tip:** *The paint should run smoothly, but make sure it's not too thin or it will run down the glass.*

7 Choose a suitable brush (the outline here was painted using a size 4 chisel writer's brush) and, working on the 'second surface', paint around the outline of the number.

Work backwards through the layers of colour - the outline first, then the
block colours

8 Allow each layer to dry for eight hours
or overnight before applying any other
paint over the top. Following the diagram
(right), work through the layers of your
design. If you are following the colours
used in this project, you will need to
paint in this order:
1. red outline
2. dark blue outline and cross-hatching
3. inner dark green shadow line
4. solid green fill
5. light blue fill.
Tip: *You may find that some colours need
two coats to achieve maximum opacity,
so check that you are happy with the
results each time before moving on
to the next layer.*

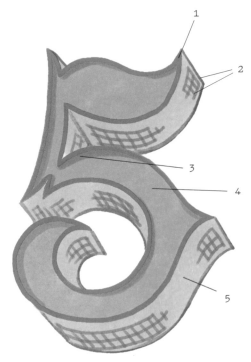

9 When painting the cross-hatching, make very sure that the lines are all parallel with the outline of the number. Add an inner shadow line with a darker colour, as shown. Because these layers don't touch, as long as you are careful you don't need to wait until the cross-hatching is dry to paint the shadow lines.

10 Next, use a thicker brush (here, a size 8 chisel writer's brush) to fill the 3D shading and the body of the letter with your colours of choice, covering the cross-hatch lines as shown on p. 135.

11 If you have made any mistakes, you can use a fresh straight-edge razor blade to remove the paint. A clean blade, flat on the glass, will remove paint without scratching the glass.

12 Leave your finished piece to dry for at least eight hours before handling it. Once it is completely dry, you can put the glass back in its frame.

Now try...

Painting on different surfaces. Signwriting enamel is suitable for use on wood, metal and some vinyl surfaces as well as glass. Remember that if you are painting onto an opaque surface, your design will need to be drawn or transferred onto it the right way around, and you won't need to paint the layers in reverse order!

Template

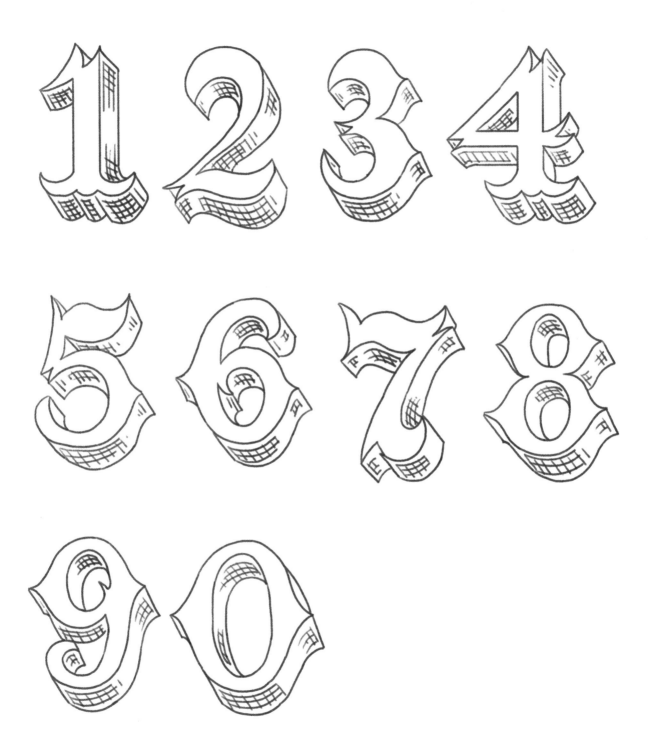

PAINTED LETTERING

Dum Medium Silentium, 1952

The artist, illustrator and poet David Jones (1895–1974) saw painted texts as a significant 'connecting link' between his drawing and writing. This example is painted in opaque watercolour, or gouache. The subtle colours are achieved through layering, enhanced by a Chinese white background, which was added afterwards. Though individual and free in style, Jones related his letterforms to real historic sources. The Latin intersperses imperial Roman letterforms ('DVM') with native British versions (the lower-case 'h'), collapsing centuries of history. Jones also liked the abstract impact of unfamiliar languages. This text quotes a Christmas *introit* (entrance) from the Roman Catholic liturgy, while the snippet of an English medieval carol also alludes to the virgin birth of Jesus Christ. The word *venit* ('he came') hinges the extracts together.

Watercolour, ink, gouache and Chinese white on paper, Great Britain, 49.5 x 61.5 cm (19½ x 24½ in.), National Art Library, V&A: MSL/1982/1262

his mother was : like dew in April

there still so all came he

DVM · MEDIVM ·
SILENTIVM ·
TENERENT·OMNIA ·
ET · NOX · IN·SVO·CVRSV ·
MEDIVM·ITER·HABERET ·
OMNIPOTENS·SERMO ·
TVVS · DÑE · DE·CAELIS ·
A · REGALIBVS ·
SEDIBVS · venit ·
IN · FESTO · NATIVITATIS·DOMINI · MCMLII

STONE WORDS

Taking inspiration from the colours and method of painting in David Jones's panel (p. 139), this project uses pebbles to open up the many possibilities of pattern and design in hand-lettering. Painting letters by building them up with a pointed brush gives the flexibility to adjust their forms and respond intuitively to the surface in a way that a rigid pen cannot.

Project by Susan Hufton

You will need

2 or more sheets A4 layout paper, min. 45 gsm/31 lbs
1 sheet A4 tracing paper
A selection of pebbles, found or bought from a garden centre. Look for interesting markings and shapes. Polished stones or any that have too rough a surface will be difficult to paint on.
HB pencil
Pointed brushes, size 0 and 1 (Handover sable hair series 33 brushes are used here)
Acrylic paints, in a selection of colours (here, mixtures of the following colours from Jo Sonja Artists' acrylic paint range are used: Titanium white, Paynes Grey, Cadmium Scarlet, Napthol Crimson, Ultramarine Blue, Green Oxide)
Clean cloth or foam block a little larger than your chosen stones

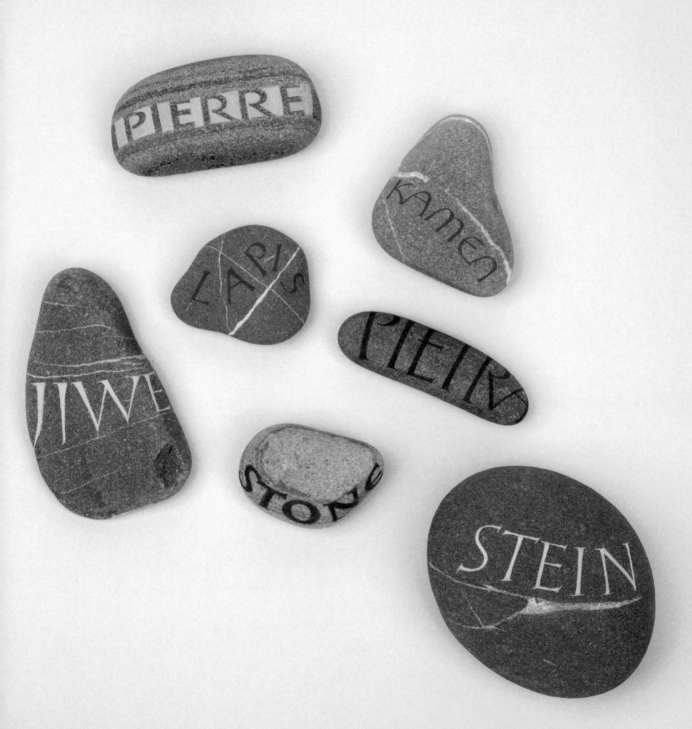

How to make

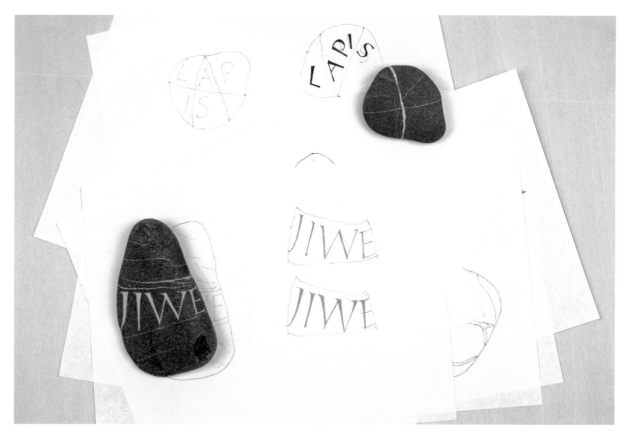

The finished word should be in harmony with each individual stone: respond to the shape, colour and surface of the stone rather than making your letters too formal.

1 Examine the pebbles, thinking about the way you want the word to look on the surface and where the best place to paint it might be. On sheets of layout paper, draw around the stones and roughly sketch any markings, slopes or hollows onto the outlines. Trace and transfer these sketches so that you have several to work with for each stone.

2 Draw onto your stone outlines, trying out different lettering styles, sizes and layouts. Altering the letters' shape, weight and spacing, as well as details such as serifs, will enable you to tailor your lettering to the stone.

3 Choose your brush and the type and consistency of the paint. The colours should work with the stone and emphasize its natural beauty - mix them if necessary. Depending on the surface of your stone, you may need to add a little water to the paint to make it flow more easily.

4 Using your design as a guide, practise painting the letters on the layout paper. Shape the paper over the stone to get some idea of what the finished one might look like and check that the letters won't be distorted by curves or bumps in the stone. Adapt the letters if necessary.

7 With your final sketch beside you, slowly begin to paint the letters onto the stones. Use small strokes to build up the letterforms. Load the brush by rolling it in the paint then removing the excess from the outside on scrap cloth or paper. This will give a finer point to your brush, and the paint will flow from the inside. Layer up the paint, rather than trying to use a single, thick layer - thick paint or an overloaded brush will not create fine, precise lines. Leave your completed stones to dry.

5 Place your stone on a piece of folded cloth or a block of foam so that it won't slip; this will also enable you to tilt it, which helps to regulate the flow of paint. You may need to twist and turn the stone as you paint.

6 You can practise painting on the reverse of the stone - this will help you to figure out how the surface takes the paint and what the brush feels like on the surface. It can be wiped off immediately afterwards using a damp cloth. **Tip:** *If you feel nervous about painting straight onto the stone, you could create guidelines for yourself by lightly drawing skeleton letters onto the stone first with a sharp pencil or white crayon.*

Now try...

Painting names or phrases onto stones to be used as paperweights. With practice and careful planning, you can paint a short quotation onto a stone, taking the words around and over the surface and perhaps following any lines or markings in the stone. Make a collection of driftwood, different stones and papers to paint on. Respond to the surface you are using and, if necessary, prepare the surface with a background paint before painting the letters.

EVERYDAY PENMANSHIP

Exercise book, 1838

'Nothing does more universally recommend a Man in any Office or Imployment than to be a dextrous and ready Penman...'

So stated the writing master John Ayres in 1716. Elegant handwriting was a highly prized skill in the 18th century, particularly for boys destined to work in a trade. George Hood was an eleven-year-old living in Derbyshire, the son of a tailor, when he filled this blank exercise book with carefully formed words and phrases between pencilled parallel lines. On the final page, he writes out the word *remembrancer* nine times. Hood went on to become a tailor, but died of tuberculosis in 1851 aged just twenty-four. The book serves as an evocative reminder of the education and life of this young man.

Folded paper pages and wrappers, England, 22 x 18.7 cm (8¾ x 7⅜ in.), V&A: B.284-2012, Given by Barbara Jones

Write with proper attentio

Write with proper attention.

Write with proper attentio

Write with proper attenti

Write with proper attention

Write with proper attention

Write with proper attention

Write with proper attentio

Write with proper attention

Write with proper attentio

Write with proper attenti

George Hood May 5th 1838,

WRAPPING PAPER

The repetitive script of George Hood's copy book (p. 144–5) is the inspiration for this wrapping paper, in which 'Happy Birthday' is written out in a number of different languages to form elegant patterns.

Project by Keiko Shimoda

You will need

2 or more sheets A3 layout paper, min. 45 gsm/31 lbs
Choice of wrapping papers, min. A2 (23¼ x 16½ in.), plus smaller scraps (tissue paper or lightweight decorative papers are good options)
Selection of pointed brushes, sizes 00-4
Square-edged brush, size 2
Watercolour or gouache paints, in a selection of colours (try to include some metallic colours: Finetec or Roberson's 'Liquid Metal' are good options)
Plate or palette
Ribbons (optional)

How to make

1 Begin by sketching out your chosen words in pencil on the layout paper. Think about their size and spacing. It doesn't matter if the lettering goes over the edges, since you will probably need to cut the paper to size for wrapping anyway. If you like, use very light pencil guidelines to keep the lettering straight; try writing with a guideline and without, to see which you prefer. A mix of both can also work well. **Note:** *In this project, 'Happy Birthday' is written out in different languages, for example:*
Bon Anniversaire
Happy Birthday
¡Feliz Cumpleaños!
كل عام و انت بخير
Alles Gute zum Geburtstag
Fijne Verjaardag
Ra Whanau Koa
Feliz Aniversário
Gratulerer med dagen
生日快乐

2 When you are happy with your lettering designs, choose your papers and paint colours. If you need to mix the paints, prepare them before you start to practise the lettering. **Tip:** *complementary colours always look good, or you could add different amounts of white to the same colour to make different shades. Metallics are also a lot of fun to work with.*

3 Practise your writing on a small sample - about A4 (8⅓ x 11⅔ in.) size - of your chosen paper. It's important to practise on the paper you will be using for your final piece, so that you can make sure that the ink does not bleed or smudge and the brush is easy to write with on your chosen surface. Try different sized brushes to see which you prefer. Make sure the paint is not too thick, as this can cause problems with lightweight or very textured papers.

Practise writing on smaller samples of the wrapping paper.

Experiment with painting on ribbons - choose colours to complement or contrast with your wrapping paper.

4 Starting with the larger letters in your design and a medium brush, write slowly and carefully onto the wrapping paper. If you are nervous about writing straight onto the paper, you could draw some very faint guidelines in pencil first.

5 Fill in the spaces with smaller lettering, using a finer brush. The letters could overlap slightly - this will give the piece a natural, freeform look.

6 Ribbons are also fun to try - pick a colour and lettering style to complement or contrast with the wrapping paper you have made. Experiment with several papers and colours - you could layer lots of contrasting designs to wrap a gift.

Now try...

Lettering on fabrics as well as papers.
Cottons, calico and silks usually take paints easily – just make sure that the surface of the fabric is not coated. If it looks shiny, it probably won't take the paints so well. Try washing and ironing your chosen fabrics to help make the surface suitable for painting.

BEYOND

WESTERN

CALLIGRAPHY

There are nearly 4,000 written languages in the world. Writing systems range from logographic scripts like Chinese, in which each character represents a word or phrase, to *abjad*s such as Hebrew and Arabic, in which each glyph supplies a consonant and the reader must infer the vowel. Calligraphies based on these scripts have developed over time to give character, expression and interest to the written word in its myriad forms.

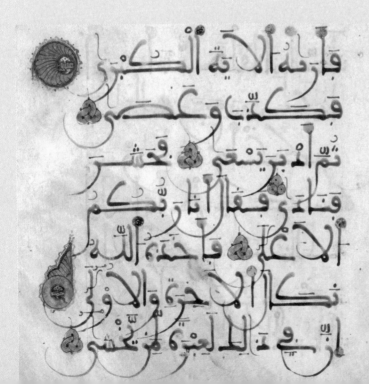

Facing page: Haji Noor Deen,
Oh Most Gracious!, 2011, 55 x 41 cm
(21¾ x 16¼ in.)

Above: Juz 30 of the Qur'an, 1330-40,
Iran, 31 x 23 cm (12¼ x 9⅛ in.),
National Art Library, V&A: MSL/1876/675

Left: Leaf from a Qur'an, 12th century,
Spain, 27 x 27 cm (10¾ x 10¾ in.).
Written in Maghribi script, with
coloured diacritical marks and gold
knots to indicate the end of each
verse. National Art Library,
V&A: MSL/1986/8

Left: Muhammad Ali, page from *Specimen of Islamic Calligraphy*, c. 1817, Iran, 36 x 29 cm (14¼ x 11½ in.), National Art Library, V&A: MSL/1858/4765

Below: *Alam* (standard), 17th century, India, 33 x 20.3 cm (13 x 8 in.). Made up of the *Nad-i cAli* prayer to Ali, son-in-law of the Prophet Muhammad. V&A: IM.163-1913

Bottom: Two birds perched on the mirrored Arabic words *Ya Fattah*, a name for God, c. 1880, Lahore, V&A: IM.17-1916, Given by Col. T. Holbein Hendley, CIE

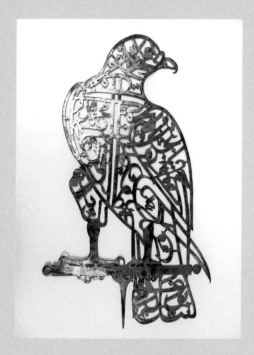

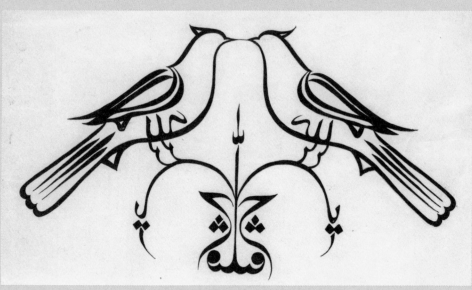

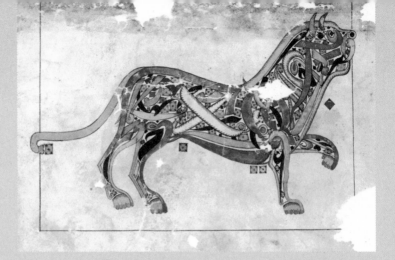

Arabic calligraphy, with architecture, has historically been the preeminent art form of the Islamic world. Arabic is the language of the Qur'an, the founding sacred text of Islam. The preservation of the Qur'anic text is of great importance to Muslims, and the precision and clarity required in writing it has given rise to works of great beauty. For most of Islamic history, the texts have been written by hand, by highly trained scribes. High-quality paper or parchment is generally used, and great care is taken in designing scripts and page layouts. Due to the belief that God alone may create living forms, Islamic religious art avoids representing human and animal forms, and as a result non-representational arts such as calligraphy have flourished; as well as being beautifully written, Qur'anic texts are often decorated with elaborate foliate or geometric designs.

Arabic calligraphy is generally written – or at least designed, in the case of inscriptions or paintings – using a pen, which was originally cut from a reed. These pens come in various sizes and forms, and the relationships between letters are determined by nib-widths and a system of proportion based on either the size of the diacritical dot or the letter *alif*, comprised of a single vertical stroke. The 13th-century Ottoman calligrapher Yaqut al-Musta'simi helped to formalize this system, and was perhaps the most significant figure in shaping the course of calligraphy in the Islamic world. He pioneered the use of pens cut at an oblique angle, now essential to Arabic calligraphy, and was also key to the development of the scripts known as the Six Pens, which remained popular throughout the Ottoman Empire and are still learned today. The lettering typically used in print and on most computers today is based on *Naskh*, one of these six scripts.

With the addition of a few letterforms, Arabic scripts can also be used for languages including Turkish and Persian. This has led to the development of many more calligraphic hands – for example the popular *Nasta'liq*, a Persian script used largely for copying literary works. *Nasta'liq* emerged in the 14th and 15th centuries and is also used for writing Urdu and Punjabi, among other languages.

Calligraphy remains an essential part of Islamic culture and heritage, and it is widely found in contemporary Islamic art. Contemporary Tunisian 'calligraffiti' artist eL Seed creates large-scale, highly political murals, while calligrapher Golnaz Fathi, one of only a few women trained to the highest level in Persian calligraphy, uses a brush and vibrant swatches of colour for her expressive, abstract works.

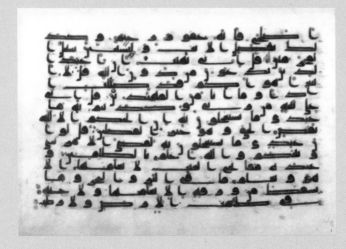

Above: *Tughra* (calligraphic monogram) in the form of a lion, 19th century, India, V&A: IS.73-1977

Left: Leaf from a Qur'an, c. 800-900, Middle East, 14 x 21 cm (5⅝ x 8¼ in.). Written in Kufic script, with coloured dots to indicate vowels. National Art Library, V&A: CIRC.161-1951

Above, left: Yoshiko Ishil, Greetings card with Japanese calligraphy, V&A: E.209-2000, Given by Tim Travis in memory of Michael Travis

Above, right: 20th century ink rubbing taken of Wang Xizhi, *The 'Heart' Sutra*, 4th century, China, 34.9 x 57.2 cm (13¾ x 22½ in.)

Left: Emperor Saga, *Cry for Noble Saicho*, 822, Japan

Calligraphy in China can be traced to 1600 BC, and traditionally uses a brush, ink stick and ink stone. Calligraphers' brushes are made from a core of shorter hairs covered by longer outer hairs that taper to a point, making them flexible, highly expressive writing tools. Ink sticks are generally comprised of lampblack, a black pigment made from soot, mixed with glue and pressed into moulds. This has become an artistic outlet in its own right; the moulds are often elaborately patterned and decorated, as are other writing accessories such as ink stones and water-droppers. Grinding an ink stick against a stone, mixed with small amounts of water, allows the calligrapher to control and adjust the consistency of their ink carefully.

The materials used in Chinese calligraphy are much the same as those used for painting, and the two art forms have often overlapped – many famous calligraphers were also painters, such as Mi Fu (1051–1107), a poet, scholar and famously expressive artist. Traditional writings on calligraphy also tie it closely to mythology and the natural world; the 4th-century Emperor Wu described the characters shown in one piece as 'A dragon leaping at the Gate of Heaven, a tiger crouching at the Phoenix Tower.' There are five main scripts, all of which are still in use today: seal script, *zhuanshu*, so-called because of its use on personal seals; clerical script or *lishu*; standard script, *kaishu*; cursive script, *caoshu*; and running script,

xingshu, which offers a middle ground between the standard and cursive scripts. The script chosen for a piece is generally tied to the purpose of the text.

The motions and gestures made while writing are traditionally very important in Chinese calligraphy. Brushstrokes not only form characters, but reveal traces of the calligrapher's state of mind as they made the piece. In contemporary practice, this has resulted in an artistic emphasis on the process of writing; calligraphy artists such as Wang Dongling have performed their work for an audience, with the writing left as a trace of the original performance piece.

Japanese calligraphy, which recognizes the same basic scripts and techniques as Chinese calligraphy, shares this emphasis on the writing process. A uniquely Japanese style of calligraphy began to develop in the Heian period, *c*. 800, around the same time as *kana* characters came into use. This new style was pioneered by three master calligraphers known as the *sanseki* (三跡), the three brush traces: Ono no Michikaze, Fujiwara no Sukemasa and Fujiwara no Yukinari.

The influence of Zen Buddhist thought in Japan resulted in the development of Zen calligraphy, first practised by Buddhist monks and often symbolized by the *ensō*, or circle of enlightenment. This is a circle drawn in one or two swift, uninhibited brushstrokes and left uncorrected as a representation of the 'no-mind' state required to create truly skilful Zen calligraphy.

Above: Mi Fu, *Poem Written in a Boat on the Wu River*, c. 1095, China, 31.1 × 556.9 cm (12¼ x 219⅜ in.)

JAPANESE CALLIGRAPHY

Yūen, 2006

Brushed by Professor Tanchū Terayama (1938–2007), a master of Zen calligraphy, *yūen* (悠遠) signifies remoteness and distance. The vertical-format calligraphy has been brushed in grass script or *sōsho*, also known as running script, using a large brush and *sumi* ink freshly ground by hand in an ink stone. In Zen terms, the calligraphy reveals the depth of the Zen calligrapher's state of being through the physical traces of ink brushed on paper in the immediacy of a moment. The characters are painted directly and spontaneously with no retouching. On the practice of Zen calligraphy, Terayama wrote: 'Immersed in the spirit of infinite space, I took up the brush. Even though one may enter into this spirit with time and practice, expressing it in finite space requires technique. The best approach is to study extensively the work of the masters who have achieved this spirit. Then, nothing remains but to forget their work and simply wield the brush freely.'

Sumi ink on paper, cursive script, Tokyo, 136 x 64 cm (53½ x 25⅛ in.), V&A: FE.56-2008, Given by Mrs Yō Terayama, Bequeathed by the artist to the V&A

JAPANESE CALLIGRAPHY

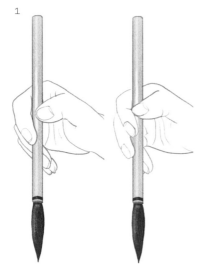

An ink stick and ink stone are generally used to make ink for brush lettering. For more information, see pp. 12–13. Make sure you have a good pool of ink ready to use before you begin practising your lettering.

The brush should be held upright, as shown (1). Try to hold it in the middle when you are writing medium-sized letters. The higher you hold the brush, the more fluidly it will move, making it easier to write larger letters. To write smaller letters, hold it closer to the tip. The line's thickness can be controlled by pulling the brush upwards (2) or pressing it down (3).

Practise individual strokes on scrap paper first. Make sure to pause for 2 seconds at the beginning and end of each stroke. This will create the thick, plentiful 'stops' you see in the sample characters on the opposite page.

Sideways strokes
Sideways brushstrokes should always be made from left to right. Finish the line slightly higher than you started it.

Vertical strokes
Vertical strokes should move downwards, and must be made slowly – keep pressing your brush into the paper all the way.

Dots and jumps
Your brush should land on the page from the tip. Slowly press down and move away again. If the stroke needs to sweep out, when removing the brush, gently sweep the tip in the direction of your next stroke– don't press too hard.

When you are comfortable with the individual strokes, practise a few of the characters shown opposite, remembering when to pause. The movements should be continuous from start to finish (see page 163). It is fine to have lightly inked areas in the middle of a stroke, where the brush moves more quickly. Keep writing until you are satisfied with the results.

Character examples

Often, the beginning or end of the strokes will overlap with strokes that have already been drawn, which means that start and end points are not always obvious. Follow the diagrams below carefully to practise writing a few different characters.

air, mood, energy

harmony

compassion

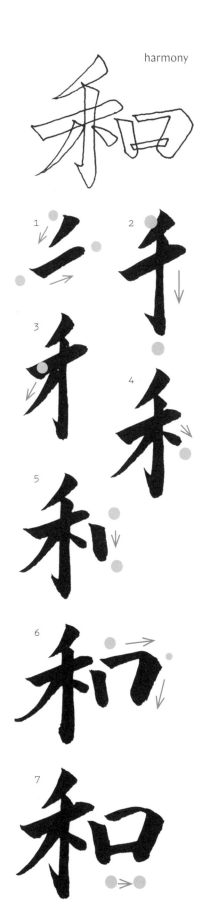

JAPANESE GREETINGS CARD

Japanese calligraphy traditionally uses a brush rather than a pen, and the strokes used to create each character are made in a particular direction and order. Here, the character *kokoro*, which means soul or heart, the place where emotions are felt, is written on *washi* paper, a traditional Japanese handmade paper, and used as the centrepiece for a greetings card.

Project by Keiko Shimoda

You will need

2 or more sheets A4 layout paper, min. 45 gsm/31 lbs

1-2 sheets A5 *washi* paper, 45 gsm/ lightweight

Chiyogami decorative paper(s)

1 pre-made card, or 1 sheet of A5 card, 300 gsm/140 lbs, neatly folded in half

Pointed brush, size 2 (here, the length of the brush tip is 1.5 cm (⅝ in.) - generally, shorter-tipped brushes will be easier to work with)

Black stick ink (or bottled ink, if preferred)

Ink stone

Water dropper

A4 or larger black felt mat

Glue stick or paper/card glue

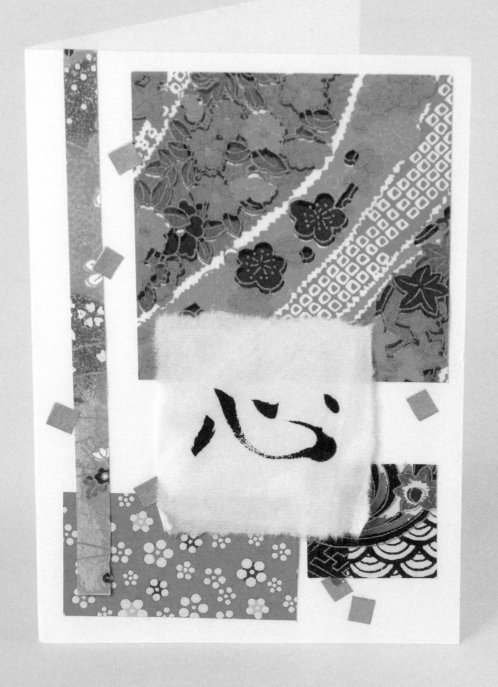

How to make

1 Prepare the stick ink, following the instructions on p. 13. Test the ink on the layout paper to make sure you have reached the desired shade - if you prefer a greyer ink, you can spend less time mixing the ink or add a little more water to the stone.

2 Once you are happy with the ink, start practising the *kokoro* character on your layout paper. Make sure to complete the strokes in the correct order (see p. 163), and keep writing until you are happy with how it looks. You could also practise some of the characters shown on p. 159.

3 To prepare the *washi* paper piece, use a 'wet cut'. Fold your paper where you would like the cut to be. Load a clean brush with plenty of water and wet the paper thoroughly along the fold before tearing it. The fibres will break easily and naturally.

4 While the torn edges dry, practise your writing on a scrap piece of *washi* paper placed on the felt mat - the mat will stop the paper from moving around and catch any ink that bleeds through. Make any necessary adjustments to the consistency of the ink.

5 Once the edges are dry, place the paper on the felt mat. Carefully write out the character, with your best practice sheets nearby for easy reference, and leave it to dry.

6 Decorate your card with coloured or patterned *chiyogami* or other decorative papers in any design you like, leaving a place for your *washi* paper piece.

7 Finally, attach your character to the card.

Choose brightly coloured, patterned or textured papers to complement your *washi* piece.

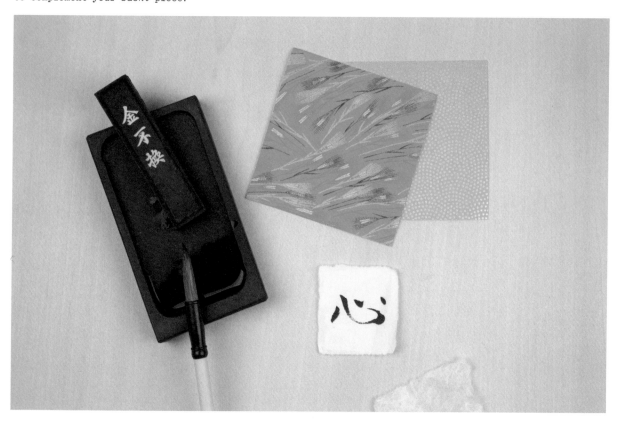

Ko ko ro

Meaning heart, soul; where you feel your emotions.

For details on individual strokes and writing speed, see p. 158. The brushstrokes should be completed in the folowing order:

1

2

3

4

Note: *The flow of the character is very important - each stroke should feel connected to the one before, following smoothly from start to finish. Try not to break the movement of the brush, even when it is not touching the paper.*

Now try...

Introducing raised elements to your cards.
Use foam 'spacers' to float some parts of the collage – you could emphasize the character by backing and floating the *washi* paper piece, or create a more complex floating design around the character.

ZOOMORPHIC CALLIGRAPHY

Bird Drawing, 19th century

This late-19th-century zoomorphic composition is made up of the first verse of the Qur'an, the holy book of Islam: *Bi-smi llāhi r-Rahmāni r-Rahīm* (بِسْمِ اللهِ الرَّحْمٰنِ الرَّحِيْمِ), 'In the name of God, the most compassionate, the most merciful.' The neckpiece consists of the two dots of the letter yā and the ring of the letter mīm, from the name al-Rahīm, 'the most merciful'. The feathers on the tail are emphasized by the repetition of the *alif* character. The word Allāh, God, has been located in the centre of the composition, on the wing, framed by the word al-Rahman, 'the most compassionate'. The layout of the words may symbolize that the hawk's flight – the ascent of the soul – is only possible with God's compassion.

Drawing in black ink on paper, Lahore, 37.2 x 25.5 cm (14⅜ x 10 in.), V&A: IM.16-1916

CALLIGRAPHIC BIRD POSTCARDS

In calligraphy, letters are made up of separate strokes to be learned and practised (see p. 16). This takes discipline and patience – but there is nothing to stop you using a calligraphy brush or pen to draw pictures. This will keep your writing interesting – and the motions required for drawing are even more varied than than those needed to write an alphabet. A study of the anatomy of Latin letterforms and the names given to their parts – spur, ear, arm, shoulder, spine, tail, waist, beard, neck, leg and beak – has inspired these charming bird illustrations.

Project by Douglas Bevans

You will need

5 or more sheets A4 cartridge paper, 140 gsm/90 lbs
10 or more blank postcards, min. 300 gsm/ 140 lbs (you can make these from an A3 sheet; rule it into equal sections and, using a craft knife, metal ruler and cutting mat, cut it into postcards)
Selection of small, flat brushes, sizes ³⁄₁₆ in., ¼ in., ⅜ in. and ½ in.
Pointed brush, size 00 or 0
Gouache paints, in at least three colours
White pencil or pen and ink (optional)
30 cm (12 in.) ruler with metal edge (optional)

How to make

Use three or four colours to create detailed birds from your letter strokes.

1 When you first learn how to write, letter strokes must be practised individually. These same strokes can also be used as the basis for interesting, creative designs. In the piece on p. 165, a bird is formed of letters which make up a verse from the Qur'an. Here, Roman capitals (see p. 34) have been broken down into their separate elements. On your cartridge paper, try writing out a few of these letters with the strokes separated.

2 Try to think about the strokes as individual elements, and begin rearranging them to see what bird-like shapes you can make from them.

3 Try minuscule letters too - sometimes the strokes may not need rearranging at all! With a few small additions, the letterforms will begin to take on their own character.

4 Try using different coloured paints to create more complex birds. Draw strokes in the first colour, and allow them to dry before adding the second colour.

Now try...

Once you've mastered bird shapes, try making different animals from your letter strokes. You could work on a larger scale, combining the letter strokes for whole words or phrases. Think about the relationship between the word and the image you make from it. Look at the examples on pp. 150, 153 and 165 for inspiration!

5 Repeat this process using three or four different colours, and use the pointed brush to add finer details like feet or beaks. Your lettering doesn't have to be legible - try combining strokes for several letterforms into one bird.

6 Transfer your favourite designs on to blank postcards, remembering to allow the ink to dry between each colour. Once your birds are completely dry, use a ruler and white pencil or ink to add dividing lines and space for an address on the reverse of the card.

GLOSSARY

arm A horizontal letter stroke that does not connect to a stroke or stem at one or both ends, e.g. the top stroke of T, the upper diagonal of K.

ascenders The part of a letter that extends above the x-height – as in b, f

baseline Line that provides a bottom edge from which to measure x-heights; also the line on which the body of the text rests.

body The part of a letter which falls within the x-height and is not an ascender or descender.

book hand A handwritten script designed to be highly legible, ordinarily used for writing out running text in a manuscript.

Book of Hours Book of prayers and devotional texts intended for an audience outside religious orders.

bowl The curved or circular part of a letter, usually connected to a stroke or stem at both ends.

crossbar The horizontal 'cross' stroke in e.g. f and t.

cursive Any style of writing in which some characters are written joined together (but not as ligatures), without taking the pen off the page.

deckled edge A feathery or fibrous edge, named for the 'deckle', the frame in which paper is made. Can be a desirable decorative element.

descenders The part of a letter that extends below the x-height – as in j, y

diacritics A glyph added to a letter or character to change its function.

This might change the pronunciation, or be used to indicate vowel sounds.

family group Groups of letters with related characteristics, which can be practised together to help familiarity with a particular script.

flat termination The visible beginning or end of a letter stroke, e.g. the top and bottom of the vertical strokes in H or I.

Gradual Book of songs sung by the choir in a Catholic Mass.

gutter The centre fold of a book or spread when it is laid open.

hairline Very thin letter strokes.

Humanism In the Renaissance, the study and revival of the cultural, literary, artistic and philosophical legacy of classical antiquity.

insular script Script developed in Ireland around the 7th century, which spread to England and Europe and influenced Carolingian minuscule.

ligature Two or more letters joined together as a single character, e.g. æ.

Lombardic Decorative upper-case letters used in medieval manuscripts.

majuscule Large lettering – not necessarily upper-case – in which the letters are all the same height.

margins The edges or borders of a page, surrounding the text area.

minuscule Small, lower-case lettering with ascenders and descenders.

nib widths System of proportional measurement in which the x-height of a script is determined by drawing a set number of short, horizontal pen-strokes on top of one another.

parchment Writing material made from untanned, specially prepared sheep, older calf or goat skins.

Psalter Copy of the Christian Biblical Psalms.

scriptorium A room – or later, a whole organisation – for the copying, writing and decoration of books. Originally attached to monasteries.

serif A short pen stroke attached at an angle to the start or end of a letter.

spacing The amount of room left between letters/characters and between lines (sometimes called interlinear spacing).

text area/block The space available for text on a page or spread.

vellum Writing material made from untanned, specially prepared calf or sometimes lamb skin.

Versals Large capital letters written as an outline and filled in, often used to write initials or display text.

weight The thickness – or perceived 'heaviness' – of the line. Weight can be varied by changing nib size or the x-height.

x-height Height of the body of letters in a script. The height of the x is used to determine the height of the rest of the lettering (ascenders and descenders will extend above or below the x-height).

ABOUT THE MAKERS

Douglas Bevans

Douglas Bevans began his formal art studies at San Francisco Art Institute, only four blocks away from his family's typesetting shop, where his interest in letters began. He became a freelance illustrator after further studies at Art Center in Los Angeles. Attracted by the variety of English illustration, he moved to London in 1985. The opportunity to teach Graphic Design at Central Saint Martins College brought together his interest in lettering and image making. He now teaches at the Royal College of Art, and feels that drawing and lettering find their most agreeable combination in calligraphy.

Emiko Hashiguchi

Emiko Hashiguchi came to England from her native Japan to pursue her passion for calligraphy. She studied calligraphy at Roehampton University and proceeded to work professionally as a calligrapher while continuing her studies. She was elected a Fellow of the SSI (Society of Scribes and Illuminators) in 2012. Emiko currently works as a freelance calligrapher and teaches calligraphy courses in the London area. She enjoys working on historical calligraphy styles to explore new ideas.

◎ @emikohashiguchi

Jack Hollands

Jack Hollands graduated from University of the Creative Arts London with a first class honours degree in Graphic Design before carrying out a traditional signwriting apprenticeship with an established signwriter. He now works independently in London, on projects from residential signwriting to branding, and also takes part in workshops with experienced and up-and-coming signwriters.

www.signwritingjack.com

◎ 🐦 @signwritingjack

f signwritingjack

Susan Hufton

Susan Hufton studied at Roehampton Institute. She teaches workshops and courses at all levels in the UK and around the world, and has made public and private commissions using a variety of materials. Her work is included in the Victoria and Albert Museum and Crafts Study Centre collections and is exhibited regularly. She writes about calligraphy and lettering for publications in the UK and USA. Her particular interest is in the detail of letterforms and she designs letters that respond to the needs of the chosen text and purpose of the work.

www.susanhufton.co.uk

◎ @suehufton2018

Keiko Shimoda

Keiko Shimoda is from Japan, and started to learn Japanese calligraphy at the age of four. She has been learning alphabet calligraphy since 1995. In 2001, she completed a year's work experience at a graphics, calligraphy and stationery studio in Greenwich, London. She became a professional freelance calligrapher in 2010. Combining her two different styles, skills and tools, she has worked on many film sets, in front of customers at events, at fashion shows and on personal commissions. A member of SLLA and SSI, she now teaches both alphabet and Japanese calligraphy in London and Cambridge.

www.kcalligraphy.com

🐦 @kcalligraphy_uk

◎ k.calligraphy

Michael Tilley

Michael Tilley's artistic interests began at a young age. Influenced by cult films, posters and album artwork, he developed his skills by completing an Art Foundation Diploma at UCA Epsom, where his love of hand-lettering really began. He has completed projects for Soho House, Simmons bars, Everyman Cinemas and street food businesses among other bespoke work. He enjoys the opportunity his work offers to keep the craft of hand-lettering alive, and continues to develop his work through his business and blog, 'The Blackboard Artist'.

www.theblackboardartist.com

◎ @theblackboardartist

INDEX

Page numbers in *italics* refer to illustrations and their captions.

Picture credits

8 above: Courtesy Golnaz Fathi
8 centre left: Paul Antonio @pascribe
8 centre right: Courtesy Susie Leiper
8 below: Courtesy Kate Forrester
9 above: Courtesy Soraya Syed, Art of the Pen. ©
RSC, 2016. Photo Gina Print
9 centre right: Courtesy Unruly Gallery,
Amsterdam
9 below left: Courtesy Gerald Fleuss
30 right: The Board of Trinity College, Dublin/
Bridgeman Images
32 centre right: British Library, London/British
Library Board. All Rights Reserved/Bridgeman
Images
85 below: Collection of The Contemporary
Museum of Calligraphy, Moscow. Courtesy
Timothy Noad
114 right: Courtesy David Kynaston
115 below: Matthew Mitchell of Bravo Boards,
Nottingham, www.bravoboards.com. Photo James
Marvin
116 left: © The Trustees of the David Jones Estate/
Bridgeman Images
125: Courtesy Edward Johnston Foundation
139: © The Trustees of the David Jones Estate/
Bridgeman Images
150: Courtesy Haji Noor Deen
154 right: The Metropolitan Museum of Art, New
York, Seymour and Rogers Funds, 1977
154 below left: From *History of Japanese
Calligraphy*, by Hachiro Onoue, 1934
155: The Metropolitan Museum of Art, New
York, Gift of John M. Crawford Jr., in honour of
Professor Wen Fong, 1984

Acknowledgments

The publishers would like to thank the V&A curators
who wrote historical texts, as follows: p. 34 Rebecca
Knott; p. 46 Michaela Zöschg; p. 60, p. 70, p. 86,
p. 94 & p. 118 Catherine Yvard; p. 102 Gill Saunders;
p. 108 Katharine Martin; p. 124 ; p. 130 Penelope
Hines; p. 138 Elizabeth James; p. 144 Hannah
Fleming; p. 156 Sarah Moate; p. 164 Bora Keskiner.
Our thanks also go to Catherine Yvard, for her
support and expertise on Western calligraphy, and to
Tim Stanley, for his advice on Islamic calligraphy.

Susan Hufton kindly allowed the re-use of technical
text and images from *Calligraphy Project Book: A
Complete Step-by-Step Guide* (1995), and provided
additional technical text and advice. We are also
grateful to Emiko Hashiguchi, for technical text
and advice on Gothic script, to Keiko Shimoda, for
technical text and advice on Japanese calligraphy, and
to Kate Edwards, for the chapter introduction texts.

Thank you to L. Cornelissen & Son, suppliers of
artist-quality tools and materials, for supporting this
project (www.cornelissen.com).

We would love to see what you create! Share your
pictures online using the hashtag #vamMaker